THE JAPANESE ART OF STONE APPRECIATION

Suiseki and its Use with Bonsai

Vincent T. Covello and Yuji Yoshimura
with a new foreword by Sonja Arntzen

TUTTLE PUBLISHING
Tokyo • Rutland, Vermont • Singapore

To Adele Astrello and Donald Sanborn

Published by Tuttle Publishing, an imprint of Periplus Editions (HK) Ltd., with editorial offices at 364 Innovation Drive, North Clarendon, Vermont 05759 U.S.A.

Copyright © 2009 Periplus Editions (HK) Ltd.

Library of Congress Cataloging-in-Publication Data

Covello, Vincent T.
 The Japanese art of stone appreciation : suiseki and its use with bonsai / by
Vincent T. Covello and Yuji Yoshimura ; foreword by Sonja Arntzen.
 p. cm.
 Includes index.
 ISBN 978-4-8053-1013-7 (pbk.)
1. Suiseki. 2. Bonsai. I. Yoshimura, Yuji. II. Title.
 NK8715.C6 2009
 745.58'4--dc22

 2009004361

ISBN 978-4-8053-1013-7

Distributed by

North America, Latin America & Europe
Tuttle Publishing
364 Innovation Drive
North Clarendon, VT 05759-9436 U.S.A.
Tel: 1 (802) 773-8930; Fax: 1 (802) 773-6993
info@tuttlepublishing.com; www.tuttlepublishing.com

Japan
Tuttle Publishing
Yaekari Building, 3rd Floor,
5-4-12 Osaki, Shinagawa-ku
Tokyo 141 0032
Tel: (81) 3 5437-0171; Fax: (81) 3 5437-0755
tuttle-sales@gol.com

Asia Pacific
Berkeley Books Pte. Ltd.
61 Tai Seng Avenue #02-12, Singapore 534167
Tel: (65) 6280-1330; Fax: (65) 6280-6290
inquiries@periplus.com.sg; www.periplus.com

13 12 11 10 09 6 5 4 3 2 1

Printed in Singapore

TUTTLE PUBLISHING® is a registered trademark of Tuttle Publishing, a division of Periplus Editions (HK) Ltd.

Table of Contents

List of Illustrations

Note: In the captions, where specifications of stones and other items are given, measurements have been listed in both the English and metric systems. In the text, measurements are given in only the English system.

Authors' Note: Throughout the book, we have provided the best available photographs to illustrate the text. In some cases, a particular photograph was a good illustration of a point being discussed, but was less than exemplary from the viewpoint of display. In these cases, we included explanatory or critical comments in the caption. It is hoped that such comments, which are based on principles discussed in Chapter 4, will be helpful to the reader.

Acknowledgments

We would like to express our gratitude to Carol Mandel, Charlotte Mandel, Richard and Dixie Shaner, Raymond Schieber, and Edward Watzik for their help in the preparation of this book. Acknowledgment and sincere thanks are also due to the following for their assistance with the manuscript and for their permission to illustrate various excellent suiseki and bonsai specimens: Sidney Gorlin, Figure 11; Horace and Connie Hinds, Figures 51, 129; Cliff Johnson, Figures 7, 9, 37, 127; Cliff Johnson and James Everman, Figures 53, 59, 64, 105, 107, 148; Cliff Johnson and Anthony Thomas, Figures 40, 50, 52, 126, 128, 134; Cliff Johnson and Robert Watson, Figure 130; Keiji Murata, Figures 16, 17, 23, 24, 28-30, 41, 42, 46, 62, 108; Edwin Symmes, Figures 113, 114-116, 117-122, 153; Melba Tucker, Figure 136; Charles Wahl, Figures 25, 27; Robert Watson, Figures 61, 132, 145; Wu Tee-sun, Figures 109, 111, 112, 123; Kanekazu Toshimura, Figures 6, 8, 15, 18, 20, 22, 55, 70, 77, 78, 83-86, 143, 144. Figures 1, 4, and 5 have, respectively, been reproduced by courtesy of the Freer Gallery of Art, Smithsonian Institution, Washington, D.C.; the Tokugawa Art Museum, Nagoya, Japan; and the Consulate General of Japan, New York.

Foreword

Who among us, when walking along the banks of a river or the shores of a sea, is not drawn to collect stones, be they small pebbles, or rocks just within our carrying capacity. The collecting itself is akin to meditation, for the preoccupations of our busy minds fade away as we focus on distinguishing the minute differences between the stones at our feet. What a moment before was an undifferentiated mass, becomes a community of individuals, each with its own marvelous suchness. Thus begins appreciation. This book is devoted to the Japanese art of appreciating such small-scale stones, known as *suiseki*.

As the chapter on historical background touches upon, the appreciation of stone has a long history in China, which can be dated back to pre-history and the veneration of jade. Disks and other jade objects constitute one of the important categories of pre-historical artifacts in China. The first term for special stones in Chinese vocabulary, *guaishi* 怪石 "fantastic stones" appears in a list of imperial tribute dating back to the middle of the first millennium B.C.[1] It most likely referred to semi-precious stones like jade, but came to be the general term for stones and boulder-size rocks with unusual attributes. The term itself is instructive, however, because the Chinese taste for stone was marked from the beginning with a predilection for the strange. The prevalence of limestone along Chinese rivers and sea coasts has resulted in the natural production of stone in writhing shapes, full of hollows and holes. These twisted, verging on grotesque, forms have always been the mainstay of Chinese garden design. For more than a thousand years,

1. Edward H. Schafer, *Tu Wan's Stone Catalogue of Cloudy Forest*, University of California Press, 1961, p. 1.

huge stones of this type have been shipped from one end of China to the other for the creation of "stone forests" and "grottos for immortals." Fortunes were spent on these enterprises and their owners fretted over the difficulty, despite the enduring quality of stone, to preserve these gardens for posterity. One of the most famous cases of this was Li Deyu (787-850) whose villa at Pingquan outside of Luoyang was legendary for its rock and plant collection. Li Deyu wrote in an exhortation to his descendents, "Whoever sells even one rock or a single plant will not be considered a good offspring of mine."[2] Yet, no sooner had he died than economic and political exigencies forced his descendents to sell off the treasures, including one of his favorites, the "Rock for Sobering Up from Intoxication." Apparently Li Deyu used to lean against it, as though it were a servant, whenever he got drunk. Such notorious cases mark the point where petrofilia crosses over into petromania; readers of this book beware, it may be catching! I once had the opportunity to witness the arrival of a container load of Chinese fantastic boulders ranging in size from half a ton to five tons for the garden of a friend in England who is a dealer in Chinese art. He had long been seduced by the smaller scale "scholar stones" (of the type illustrated in figure 2), but he dreamed of creating a Chinese stone garden for himself. The rocks themselves apparently were not so expensive, but shipping them half-way round the world was, needless to say, a fantastic extravagance. When they arrived in Britain, the credulity of Her Majesty's Customs' agents was strained by the bill of lading listing the contents of the container as only "Chinese rock" and ordered a thorough check of the shipment. When it was revealed to be just what it said, my friend was still charged for the inspection on the grounds that he had "caused mischief," presumably with such a whimsical import. Such are the dangers of petromania.

The appreciation for stone in Japan has a long history too. While it has been influenced deeply by the Chinese tradition, it also, as is pointed out in the introductory chapter, has its own independent root in the native religion of Shinto. Animistic beliefs in Shinto led to the veneration of natural stones in situ as dwelling places of spirits. Perhaps this explains to some degree why the taste in stone in Japan from the

2. Xiaoshan Yang, *Metamophosis of the Private Sphere: Gardens and Objects in Tang-Song Poetry*, Harvard University Press, 2003, p. 18.

beginning has tended to a preference for the restrained and simple, a predilection subsumed under the *wabi, sabi, shibui, and yugen* aesthetics dealt with in Chapter 2 of this volume. It is certain that immense sums have been expended in Japan for the creation of private gardens, but such creations have not generally achieved legendary status. Even the affection felt for stones has had a more restrained character in Japan. As evident above in the example of Li Deyu, a personification of stones in China has been part of their appreciation. Here is a charming example of that kind of anthropomorphic view from the conclusion of a poem by Bai Juyi (772-846), who is coincidentally the most beloved of all Chinese poets in Japan. In this long poem, Bai Juyi eulogizes a pair of rocks in his garden and ends with the following:

> Each man has his own preferences:
> All things seek their own companions.
> I have come to fear that the world of youth
> Has no room for one with long white hair.
> I turn my head and ask this pair of stones:
> "Can you be companions for an old man?"
> Although the stones cannot speak,
> They agree that we three shall be friends.[3]

By contrast, traditional Japanese poetry tends to present rocks and stones simply as part of a natural landscape. Here is one example by Fujiwara no Shunzei (1114-1204),

> In one place, frozen,
> in another, breaking up,
> the mountain river
> sobs between boulders,
> a voice in dawn's light.[4]

There is a slight feeling of personification in the verb "sobs" but the boulders are not depicted as having human attributes. Rather than an-

3. Author's translation, but I first found the poem in Yang's *Metamophosis of the Private Sphere*, and followed Yang's citation of the original Chinese on p. 101.
4. Katsu koori/ katsu wa kudakuru/ yamagawa no/ iwama ni musebu/ akatsuki no koe, poem no. 631 in the *Shinkokinshu* poetry anthology. (c. 1200)

thropomorphize the natural elements in this scene, the poet's mind has merged with the scene. This is also evident in one of the most famous haiku on stone and sound by Basho (1644 to 1694),

Such stillness, sinking into the stones, the cicadas' cries.[5]

Perhaps this long tradition in Japan, nurtured by poetry, of cultivating attentiveness to the special qualities in the most ordinary of natural scenes has contributed to a love for stones characterized by a quiet, unexaggerated beauty.

The greater part of this book is reserved for an overview of the Japanese canons of stone appreciation, as well as practical matters related to collecting, altering, and displaying stones. When I was first approached to write a foreword for this book, I was at a loss as to what I might be able to provide, given that I am not an expert in Japanese stone connoisseurship. At first, I felt that I lacked the frame of reference to fully appreciate the classification system. The next morning, however, after reading the book, I wandered out in my garden and suddenly one of the rocks I had casually gathered from the beach took on new and exciting significance. I should explain that I live on one of the Gulf Islands off the Pacific Northwest coast of Canada. The geological foundation for the islands is sandstone and shale, but over the shale beaches are strewn a great variety of stones that have been ground and polished by an ancient glacier before being dropped as the glacier receded. The stone I noticed that morning was smooth, dark gray-green, with three white lines descending its sides in a pleasingly random pattern. It came to me, of course, this is a "Thread-waterfall stone" (Itodaki-ishi) and I rushed inside to fetch the book and look it up on p. 34. There was the description and the illustration, Fig. 41, to confirm it. I derived such pleasure from this recognition, and the stone has become infinitely more precious. This experience made me reflect on the importance of classification systems to help us recognize differences among the myriad phenomena surrounding us. Naming actually enables us to see more clearly. That is what the classification system in this book did for my perception of this one stone. Now, I am contemplating ways

5. Shizukasa ya/ iwa ni shimiiru/ semi no koe, from Basho's Oku no hosomichi, "Narrow roads to the Back Country." Basho composed this haiku on a visit to Ryushaku Temple in Yamagata province.

to create a suitable display for it, perhaps improvise a driftwood stand to suggest a surrounding ocean, or find a suitable clay pot in which to immerse it in sand. All the aesthetic advice and instructions for display that I would need for such a project are available in this volume. Thus, I can recommend this book highly to anyone with a natural but untutored penchant for collecting stones. You will find your enjoyment of this pastime much enhanced.

In this essay, I have used "stone" and "rock" as though they were interchangeable in usage, but one notes that the title of this book is indeed, "The Japanese Art of Stone Appreciation." I would like to close with a poem by Naomi Wakan, a Gulf Island poet, that contemplates the distinction between rocks and stones. She, like the authors of this book, comes down resolutely on the side of "stone" when one is dealing with something to be aesthetically appreciated.

Are Rocks Stones?
Stones are quiet things
gathered on beaches
shifted about in pockets.
Stones are tumbled together
until, become gem-like they are viewed with awe.

Rocks are torn from moons
and other exotic places;
shredded in labs for what their innards might reveal.
Rocks are attacked with cleats
and picks and Vikings who seek
to conquer, or, as in the inevitable
cycle of things, themselves
be conquered in turn.

Stones are placed in courtyards
and gazed at patiently for years
until there are signs of growth.[6]

Sonja Arntzen

6. Poem by Naomi Wakan, from *Gardening*, Bevalia Press, 2007, p. 12. Reprinted with permission from the author.

Introduction

Suiseki are small, naturally formed stones admired for their beauty and for their power to suggest a scene from nature or an object closely associated with nature. Among the most popular types of suiseki (pronounced *suu-ee-seck-ee)* are those that suggest a distant mountain, a waterfall, an island, a thatched hut, or an animal (Figs. 28-30).

The art of suiseki is believed to have originated some two thousand years ago in China, where small stones of great natural beauty were set on stands to represent legendary islands and mountains associated with Buddhist or Taoist beliefs. In the sixth century A.D., emissaries from the Asian mainland brought several such stones to Japan. The Japanese adapted the art to their own tastes and have practiced it to this day.

Suiseki are traditionally exhibited on a carved wooden base or in a shallow tray. When formally displayed, suiseki are often accompanied by *bonsai,* dwarfed trees trained to grow into pleasing shapes. The term *suiseki* means literally "water stone" 水 *sui,* water; 石 *seki,* stone or stones). It is derived from the ancient custom of displaying miniature landscape stones in trays filled with water, and from the association between suiseki and classical Oriental landscape paintings of mountains and lakes. Prior to the Meiji era (1868-1912) a variety of other terms were used interchangeably to describe miniature landscape stones, including *bonseki, bonzan, chinseki, kaiseki,* and *daiseki.* By the latter part of the nineteenth century, however, the use of the word *suiseki* was firmly established among Japanese collectors, and it assumed precedence over all other terms.

In the last thirty years the popularity of suiseki in Japan has greatly increased. Numerous books in Japanese have been written on the sub-

ject, and annual exhibitions of suiseki are held in nearly every large Japanese city. Collectors roam the countryside looking for high-quality specimens, and some of their finds are sold for thousands of dollars.

Within the last decade an increasing number of non-Japanese, particularly Western bonsai and tray-landscape enthusiasts, have discovered the special beauty of suiseki. These new collectors share with their Japanese counterparts the challenge of searching for suiseki among thousands of ordinary stones, and the exhilaration of discovering a specimen that will be admired for generations to come.

CHAPTER 1

Historical Background

For thousands of years the Japanese have looked upon stones with a spirit approaching veneration. It is therefore not surprising that Empress Regent Suiko greatly admired the miniature landscape stones first brought to Japan as gifts from the Chinese imperial court during her reign (A.D. 592-628). Reflecting the Chinese taste of the period, these imported stones were often fantastically shaped, with deep folds and hollows, pass-through holes, highly eroded surfaces, convoluted forms, and soaring vertical lines (Fig 2). Stones of this type were popular in Japan for many centuries and were an important item of trade (Fig. 1).

During this early period of development, miniature landscape stones were appreciated both for their natural beauty and for their religious or philosophical symbolism. For Buddhists, the stone symbolized Mount Shumi, a mythical holy mountain that was believed to lie at the center of the world. (Fig. 31). For Taoists, the stone symbolized Horai, the Taoist paradise (Fig. 32). For believers in the Chinese philosophical system of *yin-yang* (in Japanese, *in-yo*)— the ancient doctrine that attempts to explain nature's workings according to two opposing yet complementary principles—a miniature landscape stone set in water symbolized the two fundamental forces of the universe. The stone represented yang characteristics: hard, solid, unyielding, dry, hot, bright, strong, forceful, rough, and penetrating. The water represented yin characteristics: soft, void, yielding, moist, cool, dark, mysterious, weak, passive, delicate, sensitive, and receptive.

The Japanese, appreciation for miniature landscape stones was also highly influenced by Shintoism, the native religion of Japan. For the Shintoist, specifically designated natural stones and other elements in

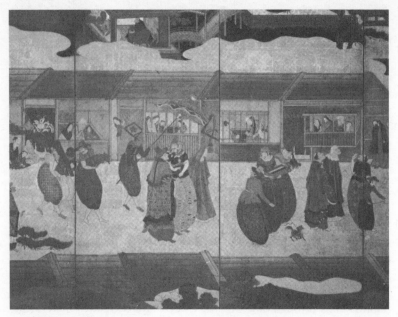

Fig 1. Section of a sixteenth-century Japanese screen entitled "Portuguese in Japan." The screen shows Portuguese traders unloading stones and other imported Chinese goods from a ship.

the natural environment—the sun, the moon, and particular trees— were the abode of powerful spiritual forces or gods (*kami*). To symbol- ize the divine nature of such stones and to mark them off as places of worship, they were encircled by a thick rope of plaited rice-straw fringed with rice stalks and strips of folded white paper. A striking ex- ample of this practice is the pair of rocks in Futamigaura bay, which lie just offshore near the city of Ise on the Pacific coast of Japan (Fig. 33). For centuries these two rocks—romantically called "Wedded Rocks" (Meoto-iwa)—have been associated with Izanagi and Izanami, the male and female mythical creators of Japan.

From these diverse religious and philosophical traditions there devel- oped in Japan several forms of artistic expression based on the aesthet- ics of stones. Miniature landscape stones set in trays were one manifes- tation; however, the art of stone appreciation was particularly refined in garden design. One of the earliest and most comprehensive Japanese books on the latter art was an eleventh-century garden manual called

Detail of screen.

Fig 2. Chinese Coastal rock stone with tunnels. Height: approx. 16 inches (41 cm.).

the *Sakuteiki*.[7] It describes in minute detail the characteristics of stones and their proper positioning, advising the gardener to exercise great care in aligning them. It is warned, for example, that a stone incorrectly placed—such as a naturally upright stone set horizontally—will disturb the spirit of the stone and may bring misfortune to the owner.

The artistic appreciation of stones underwent further refinement in the centuries immediately following the writing of the *Sakuteiki*. From the thirteenth to the fifteenth centuries, however, there occurred a radical change in Japanese taste, due partly to the political developments in Japan at that time. During the latter part of the Kamakura period (1183-1333), the samurai-warrior class rose to power. Active trade and cultural exchanges with China hastened the transmission of Zen Buddhism, which won quick and wide acceptance by the samurai. Under the influence of Zen—with its emphasis on austerity, concentrated meditation, intuitive insight, the experience of absolute "nothingness," and direct communion with nature—a different type of stone came to be admired. Unlike the older Chinese stones, these new stones were subtle, profoundly quiet, serene, austere, and unpretentious (Fig. 3).

During this period of Japanese history, suiseki, as well as the tea ceremony, flower arrangement, bonsai, calligraphy, literature, painting, music, and architecture, attained new levels of refinement and perfection. Connoisseurs of miniature landscape stones would hold gatherings where participants competed with one another writing poetry about the stone on display. Stones were sometimes so highly prized that their owners carried them wherever they traveled. It is believed, for example, that the emperor Go-Daigo (1288-1339), after having failed to throw off the Kamakura regency, fled to Mount Yoshino with his favorite stone, known as "Floating Bridge of Dreams" (Yume no Ukihashi) (Fig. 4). The stone's name is a literary allusion to the retreat from the world and sorrow of Lady Ukifune, a character in *The Tale of Genji*. The emperor may have named the stone in reflecting upon his own unfortunate fate. One hundred years later, in the fifteenth century, another well-known admirer and collector of miniature landscape stones was the military dictator, or shogun, Ashikaga Yoshimasa (1435-1490).

7. Toshitsuna Tachibana, *Sakuteiki: The Book of Gardens*, trans. Shigemaru Shimoyama (Tokyo: Town and City Planners, 1976).

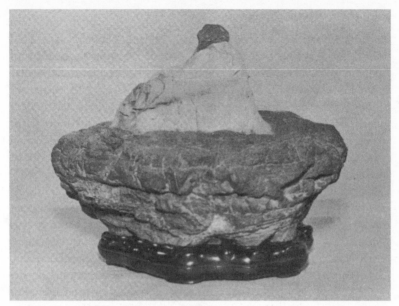

Fig 3. Human-shaped stone suggesting a sitting Zen monk or old man staring into space. The stone is named "Li Po Meditating on a Waterfall." Li Po (Li Bo) was a famous poet of the Chinese Tang dynasty (A.D. 618-907). Originally found in China on Mount Lu Shan, Fukien (Fujian) province, the stone is believed to have been brought to Japan in 1654. Over the centuries, it has had several owners, including the literati painter Rai San'yo (1780-1832). Height: approx. 9 inches (23 cm.).

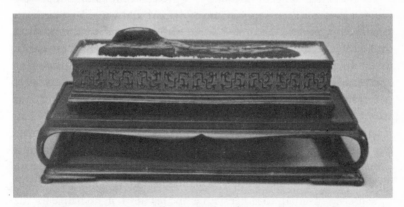

Fig 4. Distant mountain stone, "Floating Bridge of Dreams," originally found on Mount Chiang Ning (Jiangning), Chian Su (Jiangsu) province, China, and later owned by Emperor Go-Daigo (1288-1339) of Japan. The unusual tray was originally a Ming-dynasty incense burner. Height: ¾ inch (2 cm.).

It was also during the fifteenth century that most of the great dry landscape gardens *(karesansui)* were constructed. The most famous of these is the garden of sand and stone located within the grounds of Ryoan-ji, a Zen Buddhist temple in Kyoto (Fig. 5). In a rectangular space approximately the size of a modern tennis court, fifteen stones of various sizes are set on moss in an expanse of carefully raked white gravel. The grayish-brown stones, arranged in five groups, are thought to have been composed by the artist Soami, although this is by no means certain. Since the creation of the Ryoan-ji garden, thousands of observers have marveled at the perfect balance, harmony, subtle tones, and mystery of these stones. For some, the stones suggest islands dotting a vast sea, or mountain peaks rising high above the clouds. For Zen monks and others, the stones were symbols of Zen thought, serving as objects for contemplation and meditation. According to the teachings of Zen, everything finite tells of the infinite, and everything animate and inanimate is the product of the same force. By meditating on the stone, a monk could understand the essence of the stone, the essence of a mountain, and all else in the universe. To experience this essence, to become one with the stone, was to become enlightened.

In order to more clearly perceive the essence of the stone, there developed among Zen monks of the Muromachi period (1338-1573) a preference for stones stripped of all distracting elements and unnecessary detail. This, in turn, led to a preference for stones that were more suggestive than explicit, more natural and irregular than artificial and symmetrical, more austere, subdued, and weathered than ostentatious, colorful, bright, and new. Reduced to its bare essentials, the stone became a means of spiritual refinement, inner awareness, and enlightenment.

During the Muromachi period, the aesthetic tastes of Zen monks strongly influenced the Japanese ruling classes. The warlord Oda Nobunaga (1534-1582), for instance, who overthrew the Ashikaga shogunate, was known to be an enthusiastic collector of both Zen-inspired garden stones and miniature landscape stones. In one incident, he is said to have sent a miniature landscape stone, named "Eternal Pine Mountain" (Sue no Matsuyama), together with a fine tea bowl, in exchange for the Ishiyama fortress (currently the site of Osaka castle) in 1580.

Another well-known collector of stones was Sen no Rikyu (1522-1591), a sixteenth-century tea ceremony grandmaster famous for his

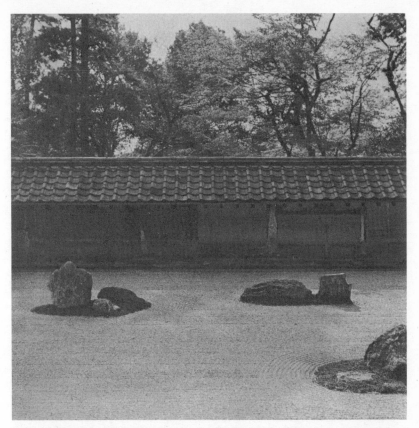

Fig 5. Section of the dry landscape garden created in the fifteenth century at Ryoan-ji, a Zen temple in Kyoto.

simple and quiet ceremonies. Rikyu, a strong admirer of miniature landscape stones, is believed to have introduced the custom of formally displaying a quiet and simple stone in the alcove of a tea ceremony hut. As part of the tradition, the stone is set in the middle of the display area and placed under a hanging scroll (Fig. 6).

In the seventeenth century one of the best-known collectors of miniature landscape stones was Emperor Go-Mizuno'o (1596-1680). In addition to being an avid collector, he is believed to have played a major role in introducing the practice of using low-rimmed oval or rectangular trays for the display of stones. Until his time, stones were customarily set in a high-rimmed (about 2 in.), black-lacquered oval tray.

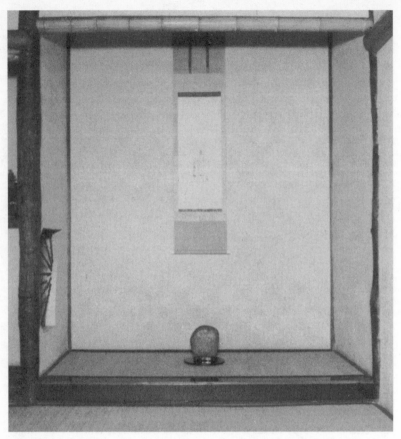

Fig 6. A formal display of a simple, quiet stone in the alcove of a Japanese tea ceremony hut.

During the Edo period (1603-1867) the development of the art of suiseki was associated with the rise of wealthy merchants and townspeople, who competed with the aristocracy for the best stones. The growth of the art was also closely associated with the Bunjin, or literati, school of painting, which flourished during the Edo period. Members of this school, mainly classical scholars who followed Chinese models, freely expressed poetic sentiments through their light wash paintings of mountain landscapes. Many of the stones collected by literati painters, such as Rai San'yo (1780-1832), have been passed down from

generation to generation as prized treasures and exist in collections today (see Fig. 3).

Early in the Meiji era (1868-1912) there was a brief period during which the development of the art of suiseki came to a virtual standstill. The wealth of the nobility and the samurai had declined, and the merchant classes had turned their attention to other art forms. By the turn of the century, however, the popularity of suiseki had revived, reaching an all-time high in the latter half of the twentieth century. Since 1961, for example, the Japanese Suiseki Association., in collaboration with the Japanese Bonsai Association, has sponsored annual exhibitions of suiseki in Tokyo. At Japan's twenty-first national exhibition in 1981, 119 suiseki were exhibited, including 2 from the United States. To promote the appreciation and understanding of suiseki, several international exhibitions have also been held: the first at Tokyo's Hibiya Park, in conjunction with the 1964 Tokyo Olympics; and subsequent ones at the Expo '70 Commemorative Park in Osaka, Japan. At the 1981 Osaka International Exhibition, suiseki collectors from around the world submitted photographic entries. The international status of the art was further enhanced in 1976 when the Japanese people presented six priceless suiseki to the United States as part of their Bicentennial gift. These stones are on permanent exhibit at the U.S. National Arboretum in Washington D.C. (Fig. 34).

CHAPTER 2

Characteristics and Aesthetic Qualities

Apart from the suiseki's aesthetic qualities, the collector is initially concerned with the size and hardness of the stone. The test for size is only approximate: the stone should be larger than a jewel or pendant but not too heavy for a person of average strength to lift. Anything larger is considered to be an outdoor garden stone (*niwa-ishi*). Miniature suiseki—stones smaller than 3 inches high and 3 to 4 inches wide—are seldom less than 1½ inches high (Fig. 35); large suiseki are rarely more than 12 inches high, 24 inches long, and 12 inches wide. Within this range of sizes the most valuable stones are those that are hard and firm. Soft and lightweight volcanic or sedimentary stones have traditionally not been used, although in recent years they have gained in popularity.

Having selected a stone of appropriate size and hardness, the collector is primarily concerned with the stone's aesthetic qualities. Does the stone have an interesting color, patina, and texture? Is the shape balanced and harmonious? Are there obvious faults or structural defects? Does the stone suggest a distant peak, an island, or some other object associated with nature? What emotion does the stone arouse? Is it one of tranquillity and serenity or one of striving and anxiety?

By asking these questions, the collector is seeking information about three interrelated aesthetic qualities common to nearly all traditional suiseki: suggestiveness, subdued color, and balance. The collector is also judging whether the stone possesses *wabi, sabi, shibui,* and *yugen*—four closely related Japanese aesthetic concepts with no direct English equivalents. Their meanings will be discussed later in this chaper.

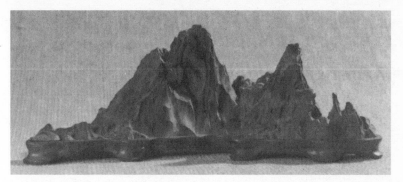

Fig 7. Near-view mountain stone. The shape of the stone suggests the mountain scenery shown in Figure 36. Height: approx. 4 inches (10 cm.). Place of origin: United States (California).

SUGGESTIVENESS

The beauty of a suiseki is derived, in part, from the power of the stone to suggest a scene or object (Figs. 7, 36). For centuries collectors have searched for stones that excite the imagination. Prior to the nineteeth century the most admired stones were those that suggested a mountain set in a lake, or an island in the sea. By the twentieth century, however, Japanese tastes had changed, and virtually any naturally formed stone that suggested a natural scene or an object associated with nature could be given serious consideration.

The suggestive possibilities of suiseki are almost limitless. The stone can transport the viewer to a lonely, abandoned thatched hut by the sea, or to a world of snow-covered mountains, hidden valleys, alpine meadows, austere mountain passes, desert plateaus, cascading water-falls, windswept islands, hermit caves, clear mountain lakes, or storm-battered cliffs. Alternatively, the viewer may see the beauty of a delicate flower eternally frozen in the stone.

Today, as in the past, suiseki are often given names which express the suggestive qualities of the stone. The names of some well-known Japanese stones are "Snow-Covered Cottage," "Moon over the Rice Paddies," and "Twilight Clouds." Suiseki are also frequently given names that express a poetic or emotional sentiment, such as "Stillness" and "Elegance." The name given to a suiseki may, in addition, evoke literary, musical, artistic, philosophical, mythological, or religious associa-

tions. Some illustrative names of American suiseki, for example, are "Mona Lisa," "Shangrila," and "Four Seasons."

Paradoxically, it is often the case that the simpler the stone, the greater its richness and expressive possibilities. The highest-quality suiseki are not exact copies of natural objects; in accordance with the Zen-related preference for simplicity, the best stones capture the essence of the object in only a few simple gestures. By presenting only a suggestion of the object, by expressing more with less, such stones stimulate and challenge the imagination, enticing the viewer to complete the picture.

Suggestion, being both ambiguous and subjective, depends in large part on the willingness of the viewer to admit a deeper beauty in the stone. Drawing on each individual's unique experience and ability to go beyond literal facts, a single stone can evoke a variety of associations, interpretations, and responses (Fig. 37).

SUBDUED COLOR

The color of most traditional suiseki is somber and subdued. Stones of deep color—especially black, gray, or the more subdued shades of brown, green, blue, yellow, red, and purple—are generally preferred to those that are light in color. Crystals and stones that are pure white have traditionally not been selected. Most collectors feel that crystals have a superficial charm that is distracting, and that pure-white stones lack character, interest, and depth.

Color is a vital element in the suggestive power of a suiseki. The color of a stone may evoke the image of the first green tender leaves of spring, the blue of a crystal-clear day in the mountains, the scarlet and crimson colors of autumn leaves, the soft gray of a morning mist, the pastel colors of the breaking dawn, or the pale pink color of a winter twilight reflected on a mountain glacier.

The most prized suiseki are those that possess a blend of subtle colors. The colors arise from deep within the stone, as if illuminated by a hidden light source. Each color veils the one beneath, creating an effect of age and mystery.

The beauty of a stone can be considerably enhanced by a subtle patina, and by deep patches of green or black suggesting cliffs and caves. To encourage the formation of a patina, some owners water their stones

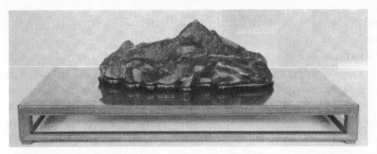

Fig 8. Distant mountain stone illustrating the interplay and harmonious balance of opposite yet complementary aspects. Place of origin: Japan (Kamogawa, Kyoto).

several times a day and store them in partially shaded places. Many collectors spray their stones with water to enhance their color while on display. Wetness brings out subtle surface tones; it also deepens the color and produces a more aged appearance. In order to achieve the same effect, many collectors frequently touch their stones, thereby transferring body oils to the stone's surface.

BALANCE

Balance is an essential element in the beauty of a suiseki, providing much of its aesthetic interest. In judging a suiseki, the collector examines the stone from all six sides (front, back, left side, right side, top, and bottom) and looks for asymmetrical, nonrepetitive, irregular, and contrasting elements in harmonious balance. These elements are especially important in choosing the "front" (i.e. the most attractive and interesting side) of the suiseki. Stones with elements that exactly repeat one another and stones that are distinctively square, round, or equilaterally triangular in shape are seldom chosen. Most collectors feel that such stones are excessively rigid and formal in feeling, and that they lack the traces of individuality that set each suiseki apart from all other stones.

Balance is created by the dynamic interplay and equilibrium of several opposite yet complementary aspects or characteristics of the stone: tallness/shortness, largeness/smallness, verticality/horizontality, convexity/concavity, hardness/softness, straightness/roundness, roughness/smoothness, darkness/lightness, movement /stillness (Fig. 8). The quality of a suiseki is determined, at least in part, by the answers given

to the following questions: Do the various elements combine to form a stable and well-grounded stone? Are the various parts harmoniously proportioned? Are any triangular shapes equilateral or asymmetrical? (Preference is given to shapes that form an asymmetrical triangle.) Is there variety in the stone's texture and in the size and shape of the peaks? Is the number of peaks odd or even? (Preference is given to an odd number of peaks if there are more than two.) Is there a pleasing balance of vertical and horizontal features? If the stone is not balanced, these varied elements will clash with one another, creating a feeling of instability and clutter. In a well-formed suiseki, asymmetrical elements combine together to create an integrated, stable, and harmonious whole.

WABI, SABI, SHIBUI, AND YUGEN

Suggestiveness, subdued color, and balance are all important qualities of suiseki. Yet the traditional appeal of suiseki is best expressed by a stone's possession of wabi, sabi, shibui, and yugen—several highly complex Japanese aesthetic concepts closely associated with Zen Buddhism, the Japanese tea ceremony, and the haiku poetry (seventeen-syllable Japanese verse) of the famous seventeenth-century Japanese poet Basho. None of these concepts can be precisely defined; nor can the qualities they express be directly seen, for they represent a mental state felt by the viewer in the presence of the stone. Although each word conveys a vaguely similar meaning and feeling, each differs in nuance and connotation.

Wabi can mean melancholic, lonely, unassuming, solitary, desolate, calm, quiet, still, impoverished, or unpretentious. Wabi is a subjective feeling evoked by an object, the classic image being an abandoned fisherman's shack on a lonely beach buffeted by the wind on a gray wintry day. *Sabi* can mean ancient, serene, subdued, mellowed, antique, mature, and seasoned, as well as lonely, solitary, or melancholic. The presence of sabi is often suggested by the patina and other signs of age or wear on a treasured antique. *Shibui* can mean quiet, composed, elegant, understated, reserved, sedate, or refined. The quiet and understated elegance of a formal tea ceremony communicates much of the essential meaning of shibui. Finally, *yugen* can mean obscure and dark, although this darkness is a metaphor for the mysterious, the profound,

the uncertain, and the subtle. The classic illustrations of yugen are the moon shining behind a veil of clouds, or the morning mist veiling a mountainside.

Considering the Japanese taste for ambiguity, it should come as no surprise that these concepts are so vaguely defined. For many collectors, the multiple meanings of wabi, sabi, shibui, and yugen can only be captured through poetry. The solitary and tranquil scenes evoked by the following lines of poetry, for example, express much of what is meant by these terms.

> To those who long for the cherries to blossom
> If only I could show the spring
> That gleams from a patch of snow
> In this snow-covered mountain village

> — *FUJIWARA NO IETAKA* (1158-1237)

> A bird calls out
> The mountain stillness deepens
> An axe rings out
> Mountain stillness grows

> — *ANONYMOUS* (Ancient Chinese Zen poem)

The qualities of wabi, sabi, shibui, and yugen are most evident in stones with worn edges that have endured centuries of weathering, erosion, and buffeting by wind, sand, ice, earth, heat, and water. Such stones are not only beautiful in their own right, but are appreciated as symbols of endurance, solidity, stability, strength, sturdiness, and character. Yet the various accretions of time—scars, lines, wrinkles, fine cracks, patina, and rusting— also reveal the relentless workings of nature and symbolically represent the impermanence, transience, evanescence, perishability, and fleeting character of all things (Fig. 38). The stone, as solid, stable, permanent, and unchanging as it may seem, is fated to disintegrate and disappear. These contrasting yet complementary aspects of the stone make the experience of its beauty deeper and more poignant.

Stones possessing wabi, sabi, shibui, and yugen tend to be especially subtle in their beauty; thus the viewer must be sensitive to nuances and minute details: fine shadings of color, slight differences in texture, and nearly imperceptible refinements of shape. When combined with other aesthetic features of the stone, it is these qualities that distinguish a great suiseki from an ordinary one. The beauty of a great suiseki often lies modestly below the surface and must be uncovered by a discriminating eye.

Some Japanese commercial establishments and collectors use a variety of methods—grinding, chipping, cutting, painting, acid burning, and polishing—to alter the stone. Occasionally a dealer or collector will also apply a coat of matte lacquer to bring out the color of the stone. Purists feel that such alterations violate the spirit of wabi, sabi, shibui, and yugen. According to the traditionalist point of view, the stone should be left as nature made it, except perhaps for some light brushing or grinding of an uneven base. Many commercial dealers argue, however, that high-quality suiseki are rarely found in their natural state. These dealers feel that some form of treatment is often necessary to meet the growing demand for quality stones.

Classification of Suiseki

Japanese collectors have traditionally used several systems to classify suiseki, including classification by shape, color, surface patterns, and place of origin. These are described below. For all major categories, the Japanese name is given in parentheses, followed by the term *ishi* or *seki*. Both of these terms mean "stone" or "stones" in Japanese. The Japanese name for a particular stone may also include the word *gata*, which is a general term meaning "shape" or "shaped."

CLASSIFICATION BY SHAPE

The most commonly used classification system divides suiseki into two major subclassifications, Scenic landscape stones and Object stones, according to the shape of the stone. Each subclassification is subdivided into further categories. Occasionally, a highly suggestive suiseki will fit into more than one category. In such cases the collector will classify the suiseki in the category that most clearly represents the shape of the stone.

Scenic landscape stones (Sansui kei-seki/Sansui keijo-seki)
Many collectors consider Scenic landscape stones to be the principal form of suiseki. Moreover, some collectors believe that the word *suiseki* may be a shortened form of *sansui kei-seki* (lit.: *san,* mountain; *sui,* water; *kei,* scenery; *seki,* stone). Under this heading there are twelve traditional categories.

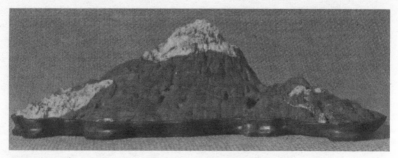

Fig 9. Distant mountain stone suggesting a snow-capped mountain. Height: approx. 7 inches (18 cm.). Place of origin: United States (California).

1. MOUNTAIN STONES (Yamagataishi): Such stones resemble a single mountain or several mountains and peaks. Those with white patches or streaks are especially prized, since these markings suggest snow fields, rushing streams, or clouds. Mountain stones traditionally have an odd number of asymmetrical triangular peaks that vary in height and shape. Ideally, the steepness of the front and back sides of the stone will be different. Also, the peaks should not be in a straight line. Some suiseki collectors divide Mountain stones into several types according to the number of peaks: Single-peak stones (Koho-seki); Double-peak stones (Soho-seki); Triple-peak stones (Sampo-seki), a pattern that is rich in religious and philosophical connotations, having its origin in the ancient Chinese pictograph for mountain; and finally, Mountain-range stones (Rempo-seki). Within the Mountain-stone category, two sub-categories are especially important.

(a) Distant mountain stones (Toyama-ishi/Enzan-seki): For most collectors, Distant mountain stones are the classic type of suiseki. Their soft contours suggest a mountain or mountain range as seen in the distance. The peak or peaks of the stone are preferably off-center and triangular (asymmetrical) in shape. All peaks should be unequal in height and shape. If the stone has more than one peak, the subordinate peaks should be lower than the main peak and should be located near the back and front sides of the stone. The rear peaks are ideally somewhat rounder and smoother than the others, while the front peaks have the deepest folds and the most roughly textured surfaces. The valleys between the peaks should be relatively shallow, permitting the eye to move effortlessly from one peak to the next (Figs. 9-12, 39; see Fig. 62).

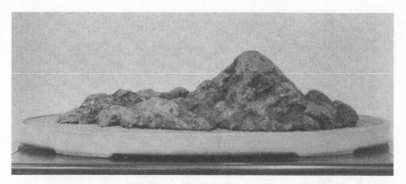

Fig 10. Distant mountain stone suggesting a series of peaks. Place of origin: Japan.

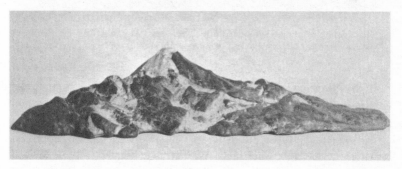

Fig 11. Distant mountain stone suggesting a snow-capped mountain range. Height: approx. 9 inches (23 cm.). Place of origin: Japan (Kamogawa, Kyoto).

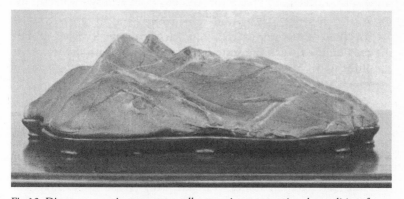

Fig 12. Distant mountain stone, an excellent specimen possessing the qualities of wabi, sabi, shibui, and yugen. Height: approx. 4½ inches (11 cm.). Place of origin: Japan (Kamuikotan, Hokkaido).

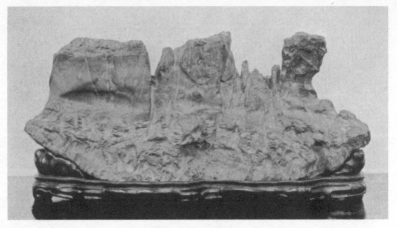

Fig 13. Near-view mountain stone with three principal peaks. The wooden insets at each end of the base enhance the feeling of stability. Place of origin: Japan.

(b) Near-view mountain stones (Kinzan-seki): These stones present a close-up view of a jagged mountain or mountain range with rough rugged contours, sheer walls, and towering spires (Figs. 13, 40).

2. WATERFALL STONES (Taki-ishi): Such stones resemble a mountain bearing one or more waterfalls. A waterfall is suggested by a vertical streak of quartz, calcite, limestone, or other white or translucent mineral. If the addition of a waterfall can improve the stone's appearance, some suiseki dealers and collectors will create an artificial waterfall using white pigment or epoxy glue. The most admired Waterfall stones are traditionally black or dark gray in color, with the waterfall appearing only on the front side of the stone. Within this category, there are three subcategories which are especially important.

(a) Thread-waterfall stones (Itodaki-ishi): Here the waterfall is suggested by one or more thin threadlike waterfalls that run down the front side of the stone (Fig. 41).

(b) Sheet-waterfall stones (Nunodaki-ishi): Here the waterfall is suggested by one or more broad waterfalls that run down the front side of the stone (Fig. 42).

(c) Dry waterfall stones (Karedaki-ishi): These stones suggest a waterfall that has dried up. No water is visible; instead the waterfall is suggested by the shape and folds of the stone (Fig. 43).

3. MOUNTAIN-STREAM STONES (Keiryu-seki): These stones suggest a

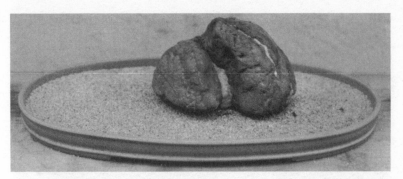

Fig 14. Mountain-stream stone. Place of origin: Japan. (The placement in the suiban could be improved by burying the stone more deeply in the sand.)

mountain stream, creek, or river rushing through a gorge, ravine, valley, or gully. The stream is often suggested by a white or translucent mineral vein that ideally runs diagonally across the stone (not directly from back to front). Occasionally the stream is hidden, with its presence suggested by folds, fissures, and other characteristics of the stone. The distinction between a Mountain-stream stone and a Waterfall stone is not always clear, since the source of the stream may be a waterfall (Figs. 14, 44).

4. PLATEAU STONES (Dan-seki/Dan-ishi): These stones suggest a terraced hillside or a series of flat plateaus or steps rising toward an imagined cliff. A traditional Plateau stone ideally has at least three steps (counting the upper surface of the stone as one step). The steps should vary in length, and the rise between each step should be sharp and straight or nearly vertical (Figs. 45, 46).

5. ISLAND STONES (Shimagata-ishi): Such stones resemble a solitary island rising out of the sea or floating in a quiet lake. Island stones are traditionally low in height and ideally have features that suggest coves or inlets. To suggest an island, the stones are almost always exhibited in a container filled with sand, water, or both. The distinction between Island stones and other suiseki is not always clear, since virtually any suiseki placed in a container filled with water can suggest an island (Fig. 15).

6. SLOPE STONES (Doha-seki/Doha-ishi): The lines and curving shapes of these stones suggest rolling hills, a river bank, or a slope rising gently toward a hill or softly contoured mountain (Figs. 16, 47).

7. SHORE STONES (Isogata-ishi): These stones are generally shallow in

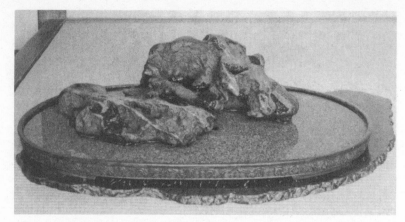

Fig 15. Island stone. For some viewers this stone also suggests two hippopotamuses with their heads raised above water. The stone is exhibited in a bronze tray filled with water. Height: approx. 4 inches (10 cm.). Place of origin: Japan.

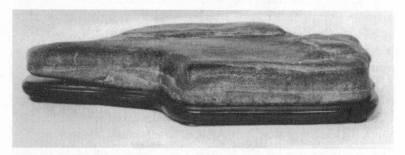

Fig 16. Slope stone. Height: approx. 1½ inches (4 cm.). Place of origin: Japan (Setagawa, Shiga).

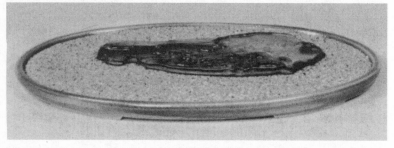

Fig 17. Sandbar stone. Height: approx. ¾ inch (2 cm.). Place of origin: Japan.

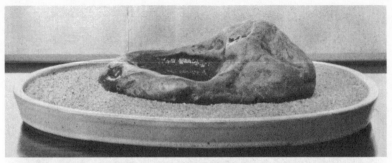

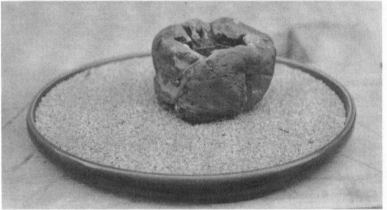

Fig 18, 19. Waterpool stones. Places of origin: Japan.

depth and may suggest a rocky or wave-washed shoreline. Within this category there are two important subcategories.

(a) Reef stones (Araiso/Araiso-ishi): These stones suggest a jagged reef or shoal (Fig. 48).

(b) Sandbar stones (Hirasu/Hirasu-ishi): The soft and smooth lines of these stones suggest a shallow sandbar or the ripples of gentle waves breaking along a quiet beach (Fig. 17).

8. WATERPOOL STONES (Mizutamari-ishi): The shallow natural hollows or depressions in such stones suggest one or more quiet mountain pools, lakes, marshes, or ponds. When on display, the depressions are often filled with water. Waterpool stones with the pool encircled by one or more well-formed mountains are rare and tend to be highly prized by collectors (Figs. 18, 19, 49).

9. COASTAL ROCK STONES (Iwagata-ishi): Such stones suggest a high,

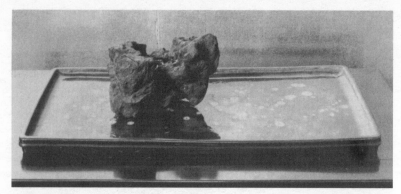

Fig 20. Coastal rock stone. The tray is filled only with water, allowing the design (suggested water lilies) on the tray's inner surface to show through. Place of origin: Japan.

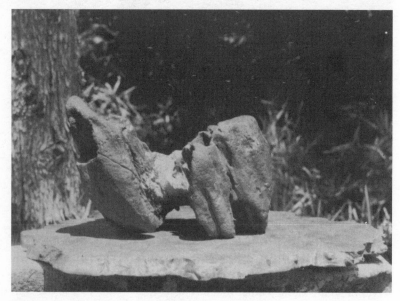

Fig 21. Cave stone. This stone has features that also suggest Tunnel and Island stones. Place of origin: United States (Mojave Desert, California).

(Facing page, from top)
Fig 22. Shelter stone. Place of origin: Japan (Kamogawa, Kyoto)

Fig 23. Shelter stone. Height: approx. 4 inches (10 cm.). Place of origin: Japan (Ibigawa, Gifu).

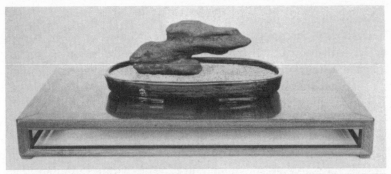

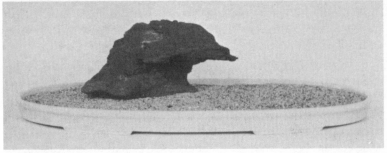

wind-swept rocky coastline; a tall, roughly shaped offshore rock; or a steep cliff at the end of a peninsula. Stones with white quartz, calcite, or limestone streaks or patches at their base are especially valuable, since these markings suggest waves breaking against the rocks (Fig. 20).

10. CAVE STONES (Dokutsu-ishi): The hollows and cavities in these stones resemble caves, caverns, or grottos. The cave is ideally suggested by a deep and dark cavity, the end of which cannot be seen. The most admired Cave stones are traditionally those where the cave slants sharply to the left or right (Fig. 21).

11. SHELTER STONES (Yadori/Amayadori): The concave shape of these stones suggests a shallow shelter or temporary refuge formed by an overhanging cliff. To be classified as a Shelter stone, the floor of the shelter should be at least partly visible. Since such a shelter might offer a mountain traveler refuge from the rain, these stones are sometimes referred to as Rain-shelter stones (Amayadori) (Figs. 22, 23, 50).

12. TUNNEL STONES (Domon-ishi): The hole or holes in these stones suggest a pass-through tunnel or natural arch. Traditionally, the tunnel passes completely through the stone (Figs. 51, 52).

Object stones (Keisho-seki)

The stones in this group typically resemble an object or subject closely associated with nature. Figures 24, 25, 53-56 show various examples. The finest stones do not exactly copy the object, but suggest it through a few subtle, simple lines and forms. There are eight traditional categories under this heading.

1. HOUSE-SHAPED STONES (Yagata-ishi): Such stones suggest different types of rustic houses. Thatched-hut stones (Kuzuyaishi), which resemble a thatched roof farmhouse, country cottage, or mountain hermitage, form an especially important category within this group. The stone ideally has an overhanging rounded or triangular roof and an eroded or recessed center (sometimes pillared). Thatched-hut stones with pillars holding up the roof tend to be highly valued.

2. BOAT-SHAPED STONES (Funagata-ishi): These stones resemble different types of boats, including wooden sailing ships, rowboats, and houseboats.

3. BRIDGE-SHAPED STONES (Hashi-ishi): These stones suggest a wooden or stone bridge.

4. ANIMAL-SHAPED STONES (Dobutsu-seki): Within this category a large number of animals, both real and legendary, are represented, including turtles (a symbol of long life), snakes, oxen, cows, dogs, horses, elephants, giraffes, mice, rabbits, cats, tigers, Chinese lions, sheep, monkeys, and dragons.

5. BIRD-SHAPED STONES (Torigata-ishi): A large number of birds are represented within this category, including cranes (a symbol of long life), herons, hawks, eagles, peacocks, ducks, sparrows, swallows, chicks, cocks, quail, and the legendary phoenix bird (a symbol of immortality).

6. INSECT-SHAPED STONES (Mushigata-ishi): Within this category some of the most popular subjects are butterflies, dragonflies, crickets, and grasshoppers.

7. FISH-SHAPED STONES (Uogata-ishi): Among the large number of fish represented within this category are carp, catfish, goldfish, and trout.

8. HUMAN-SHAPED STONES (Sugata-ishi/Jimbutsu-seki): Some of the most popular subjects for these stones are fishermen, farmers, maidens, Buddha, Kannon (the goddess of mercy), and Buddhist monks. Stones that suggest parts of the human body especially stones with sexual associations, are also prized by some collectors.

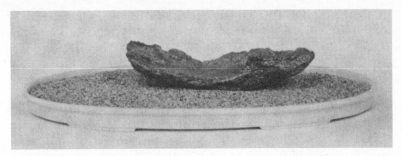

Fig 24. Boat stone. Height: approx. 2 inches (5 cm.). Place of origin: Japan (Kurama, Kyoto).

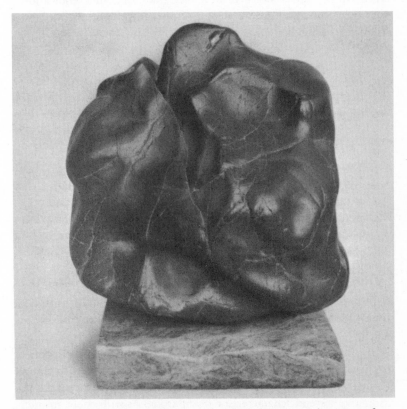

Fig 25. Object stone suggesting a bear or monster. The white spot on the upper surface resembles an eye and contributes to the stone's suggestive power. Height: approx. 10 inches (25 cm.). Place of origin: United States (California). (A larger stand would improve the display; the present one makes the stone appear unstable.)

CLASSIFICATION BY COLOR

In this system suiseki are classified by their color (Fig. 57). Color stones (Shikisai-seki) are set apart from other suiseki by their deep, subdued, and excellent color. The stone is appreciated both for its color and for what the color suggests, such as dawn, dusk, night, spring, summer, autumn, or winter. A suiseki will often be classified by its color if the color is the distinctive and predominant aesthetic feature of the stone. Good color is not, however, sufficient grounds for a stone to be classified as a suiseki. As discussed in Chapter 2, the stone must also be suggestive and must still meet certain minimum aesthetic standards. Within this classification there are several traditional subclassifications; these color subclassifications do not, however, exhaust all color possibilities for suiseki.

1. BLACK STONES (Kuro-ishi)
2. JET-BLACK STONES (Maguro-ishi)
3. RED STONES (Aka-ishi)
4. BLUE STONES (Ao-ishi)
5. PURPLE STONES (Murasaki-ishi)
6. GOLDEN-YELLOW STONES (Ogon-seki)
7. YELLOW-RED STONES (Kinko-seki)
8. FIVE-COLOR STONES (Goshiki-ishi/Goshiki-seki): The color of these stones is traditionally a mixture of red, yellow, and green (the basic colors) together with either gray, blue, purple, white, or black.

CLASSIFICATION BY SURFACE PATTERN

In this system suiseki are classified by their surface patterns. Pattern stones (Mon'yo-seki; sometimes Mon-seki) are set apart from other suiseki by the striking surface patterns formed by the stone's textures, colors, lines, imbedded minerals, and other features. Japanese collectors have traditionally preferred patterns closely associated with nature. A stone will often be classified by its surface patterns if they form the distinctive aesthetic characteristic of the stone. As with color, an interesting pattern is not sufficient grounds for a stone to be classified as a suiseki. The stone must also be suggestive and meet certain aesthetic standards. The most common Pattern stones are listed below.

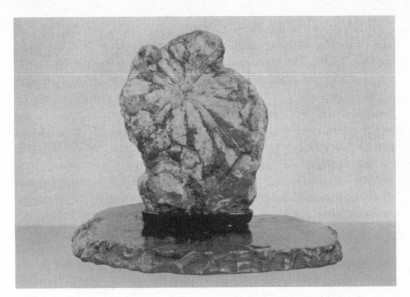

Fig 26. Chrysanthemum-pattern stone with the shape of a Coastal rock stone. Place of origin: Japan (Neodani, Gifu).

Plant-pattern stones (Kigata-ishi)
The surface patterns on these stones resemble a plant or parts of a plant. Within this subclassification the following four categories are especially important.

1. FLOWER-PATTERN STONES (Hanagata-ishi): The surface patterns on these stones suggest different types of flowers. Two categories of Flower-pattern stones are particularly important in Japan.

(a) Chrysanthemum-pattern stones (Kikumon-seki/Kikka-seki/ Kiku-ishi). The surface patterns on these stones suggest the radial design of the chrysanthemum flower (Fig. 26). Such stones are highly prized by Japanese collectors. Aside from the flower's intrinsic beauty, the chrysanthemum is a traditional Oriental symbol of immortality. The sixteen-petal chrysanthemum flower is the crest of the Japanese imperial household. Many Japanese collectors feel that the best-quality chrysanthemum stones come from the Neodani area of Gifu prefecture. Neodani chrysanthemum-pattern stones are made of tuff and are typically black, brown, green, gray, or reddish-purple, with a red or white limestone chrysanthemum-pattern imbedded in the surface. (Fig. 58; see Fig. 86).

(b) Japanese plum-blossom-pattern stones (Baika-seki). The pattern on these stones resembles Japanese plum blossoms *(Prunus mume,* not to be confused with other species of plum or apricot).

2. FRUIT-PATTERN STONES (Migata-ishi): The surface markings on such stones suggest different types of fruit, including peaches, persimmons, pomegranates, chestnuts, and citrus fruits.

3. LEAF-PATTERN STONES (Hagata-ishi): The patterns on these stones suggest different types of leaves or tree foliage, including maple leaves and pine needles.

4. GRASS-PATTERN STONES (Kusagata-ishi): These stones bear a pattern which resembles different types of grasses, including bamboo and pampas grass.

Celestial pattern stones (Gensho-seki)
The surface patterns on these stones suggest different types of celestial objects. Within this subclassification, three categories are especially important.

1. MOON-PATTERN STONES (Tsukigata-ishi) (Fig. 60)
2. SUN-PATTERN STONES (Higata-ishi)
3. STAR-PATTERN STONES (Hoshigata-ishi) (Fig. 27): Stones with surface patterns that suggest the Milky Way are especially popular.

Weather-pattern stones (Tenko-seki)
The surface patterns on these stones suggest different types of weather conditions. Within this subclassification three categories are especially important.

1. RAIN-PATTERN STONES (Amagata-ishi)
2. SNOW-PATTERN STONES (Yukigata-ishi)
3. LIGHTNING-PATTERN STONES (Raiko-seki)

Abstract pattern stones (Chusho-seki)
The patterns on these stones are abstract in design, but often suggest a subject closely associated with nature. Within this subclassification four categories are especially important.

1. TIGER-STRIPE-PATTERN STONES (Tora-ishi): The stripes on these

Fig 27. Star-pattern stone. The white marks on the stone suggest two bright stars. Height: approx. 5 inches (13 cm.). Place of origin: Japan.

stones—often formed by alternating strips of color (especially yellow, gray, brown, or black)—suggest the stripes of a tiger (Fig. 61).

2. TANGLED-NET-PATTERN STONES (Itomaki-ishi/Itogake-ishi): The crisscrossing straight lines on the surface of these stones—formed by mineral veins, fine cracks, or other features of the stone—often suggest a tangled fishing net.

3. PIT-MARK-PATTERN STONES (Sudachi): The surface of these stones is pockmarked with a large number of tiny pits or depressions. The pits look as if they were formed by small needles or by the action of particles of sand grinding into the stone.

4. SNAKE-PATTERN STONES (Jagure): The curving and winding patterns on the surface of these stones—formed by folds, furrows, mineral veins, and cracks—often suggest the writhing movements of a snake (Fig. 62).

CLASSIFICATION BY PLACE OF ORIGIN

Nearly all Japanese collectors classify suiseki by their place of origin; moreover, some Japanese collectors and books use only this system. Several locations in Japan are especially famous as suiseki collection sites,

and stones collected from these areas tend to be highly prized (p. 65). It is not always possible, however, to document with absolute certainty a suiseki's place of origin. Sometimes special qualities of the stone suggest the site from which it was collected. At other times only the person who found the stone can identify its place of origin. Listed below are the most significant Japanese suiseki classified within this system, together with a brief description of the suiseki's distinctive qualities.

Kamogawa river stones (Kamogawa-ishi)
Found in or near the Kamogawa river in Kyoto prefecture, the classic Kamogawa river stone is a jet-black Distant mountain or Slope stone. The stone is characterized by an undulating surface that alternates between waxy smooth and granular (see Figs. 8, 11, 22). Two other well-known collection sites are also located in or near the Kamogawa river, and these are described below.

1. KURAMA STONES (Kurama-ishi): The typical Kurama stone is a brown, hard granite Island, Distant mountain, or Object stone. The surface is often roughly textured with iron-rust spots (see Fig. 24). Another type of Kurama stone is a gray or brown limestone Tangled-net-pattern stone, with the surface of the stone crisscrossed by quartz veins in high relief.

2. KIBUNE STONES (Kibune-ishi): The typical Kibune stone is a dark gray or reddish-purple Mountain, Waterfall, or Mountain-stream stone. Characteristically, the stone has deep indentations and a rough, uneven surface (see Figs. 42, 44).

Setagawa river stones (Setagawa-ishi)
Found in or near the Setagawa river in Shiga and Kyoto prefectures, the typical Setagawa river stone is a hard, black Mountain or Slope stone (see Fig. 16). The surface of the stone is alternately smooth and granular. Another type of Setagawa river stone is a Tiger-stripe-pattern stone made of hard clay-slate and quartzite.

Nachiguro stones (Nachiguro-ishi)
Found in the mountains of Mie prefecture, the typical Nachiguro stone is a hard, jet-black Mountain or Plateau stone made of clay-slate. The stone is characterized by its sheer walls and shiny surfaces (Fig. 63).

Kamuikotan stones (Kamuikotan-seki/Kamuikotan-ishi)
Found in the rivers and creeks of Hokkaido, the typical Kamuikotan stone is a shiny black or dark blue-green Mountain, Slope, or Plateau stone made of clay-slate. The surface of the stone is undulating, and alternates between smooth and granular (see Figs. 12, 46).

Sado red stones (Sado akadama-ishi)
Found in the mountains of Niigata prefecture, the typical Sado red stone is a hard Mountain or Island stone that is highly prized for its rich red, crimson, or scarlet color. The stone, frequently made of jasper, may contain touches of green, gray, or yellow and is often carved or polished to bring out the color (see Fig. 57).

Ibigawa river stones (Ibigawa-ishi)
Found in the rivers and creeks of Gifu prefecture, the typical Ibigawa river stone is a hard black, bluish-black, or gray Coastal rock, Island, Waterpool, Shelter, or Waterfall stone. The stone is often made of limestone and has an uneven, irregular shape with a rough, weathered, indented, and wrinkled surface (see Fig. 23).

Sajigawa river stones (Sajigawa-ishi).
Found in the rivers and creeks of Tottori prefecture, the typical Sajigawa river stone is very similar to the Ibigawa river stone described above (see Fig. 49).

Furuya stones (Furuya-ishi)
Found in the mountains of Wakayama prefecture, the typical Furuya stone is a hard black or black-gray limestone Mountain, Waterfall, Mountain-stream, or Coastal rock stone. The stone is characterized by deep indentations, a generally smooth surface, white mineral veins running vertically down the face of the stone, and by a white or gray-white band encircling the base. When the stone is displayed, the white band is traditionally left visible. In their natural state, most Furuya stones are a mix of soft and hard stone. The peak or peaks are typically found below ground, with the white band showing above ground. The soft stone between the peaks is removed with small chisels or files, after which the stone is buffed and polished with wire brushes and other tools (Fig. 64; see Figs. 30, 35, 41).

Seigaku stones (Seigaku-seki)

Found in the mountains of Shizuoka prefecture near the mouth of the Abegawa river, the typical Seigaku stone is very similar to the Furuya stone just described. One difference is that the Seigaku stone often has deeper indentations and a somewhat rougher shape. Because a Seigaku stone almost always has several peaks, many Japanese collectors use the term "Seigaku" as a general term for any Mountain stone resembling a mountain range (see Fig. 34).

Neodani stones (Neodani-ishi)

High-quality stones representing several categories can be found in the Neodani area of Gifu prefecture. The Neodani chrysanthemum-pattern stone is particularly valued by collectors. In fact, because of the special significance and rarity of these stones, in 1952 all public lands in the Neodani area were designated as a special national treasure by the Japanese government (see p. 43 and Figs. 26, 58, 86).

COMBINING CLASSIFICATION SYSTEMS

Most Japanese collectors of suiseki label their stones using one or more of the classification systems already described. When all four systems are used (which is rare), the classificatory names are frequently listed in the following order: place of origin, surface pattern, color, and shape. After the last classificatory name, the poetic name is often indicated. To illustrate, a Japanese collector might give a suiseki the following name: Kamogawa river stone, Pitmark pattern, Jet-black, Distant mountain, Shangrila (Kamogawa-ishi, Sudachi, Maguro, Enzan, Togenkyo). Suiseki collectors in other countries generally assign less importance to the stone's place of origin, and often list classificatory names in the following order: shape, color, surface pattern, place of origin, and poetic name.

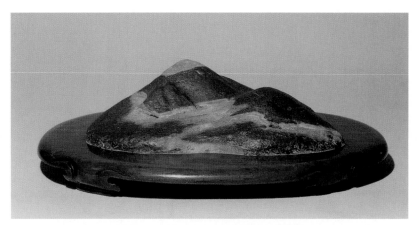

Fig. 28. Distant mountain stone, "Sacred Mount Fuji." The stone suggests a distant snow-capped mountain covered with mist and dotted with small caves. At one time this suiseki was owned by Uesugi Harunori (1751-1822), lord of the Yonezawa clan. Height: approx. 3 inches (8 cm.). Place of origin: Japan (Kimengawa, Yamagata).

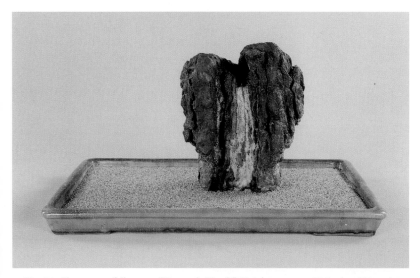

Fig. 29. Sheet-waterfall stone, "Dragon's Head." Height: approx. 12 inches (30cm.). Place of origin: Japan (Iyo, Ehime).

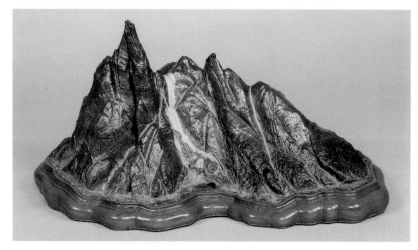

Fig. 30. Near-view mountain stone with a waterfall. Height: approx. 6 inches (15 cm.). Place of origin: Japan (Furuya, Wakayama).

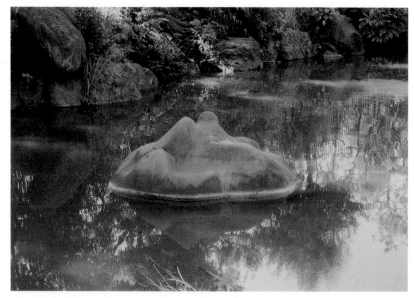

Fig. 31. Japanese garden stone suggesting the mythical Mount Shumi.

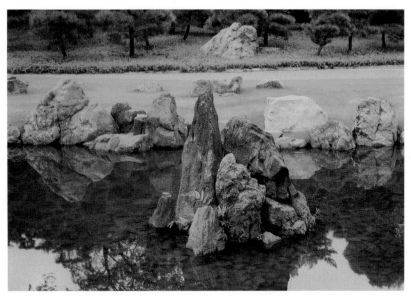

Fig. 32. Japanese garden stones suggesting Horai, the Taoist paradise.

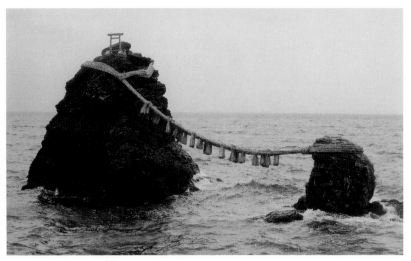

Fig. 33. The Wedded Rocks at Futamigaura, Mie, Japan.

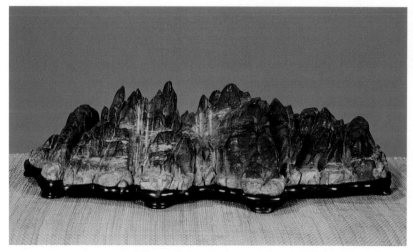

Fig. 34. Mountain stone suggesting a range of peaks, one of six suiseki in the collection of the U.S. National Arboretum. Height: approx. 4 inches (10 cm.). Place of origin: Japan (Seigaku, Shizuoka).

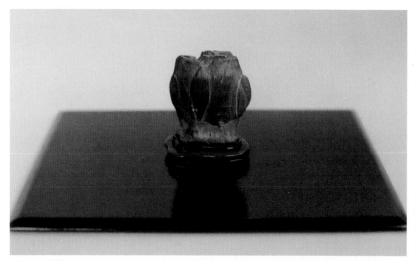

Fig. 35. Miniature Coastal rock stone. Height: approx. 3 inches (8 cm.). Place of origin: Japan (Furuya, Wakayama).

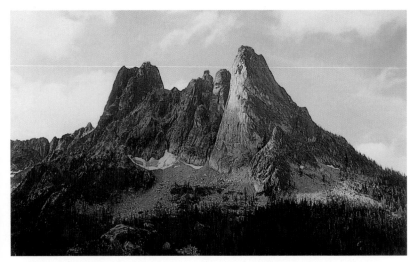

Fig. 36. Close-up view of mountains of the Cascade Range in the United States (Washington). Refer to Figure 7.

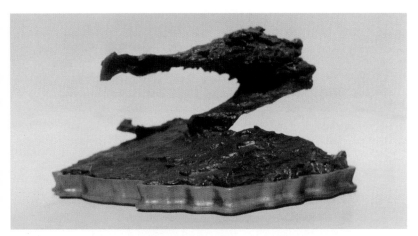

Fig. 37. Object stone that elicits a variety of associations. From one perspective the suiseki suggests the head of an alligator, pelican, or dragon. From another angle it suggests the head of a young woman with her hair blowing in the wind. The stone can also be appreciated as an abstract form. Height: approx. 4 inches (10 cm.). Place of origin: United States (California).

Fig. 38. Distant mountain stone expressing the qualities of wabi, sabi, shibui, and yugen. It has been named "Mount Hakkai" because of its resemblance to that mountain in Niigata, Japan. The stone is one of six in the collection of the U.S. National Arboretum. Height: approx. 5½ inches. (14 cm.). Place of origin: Japan. (The placement of the suiseki could be refined by moving it off-center to the left of a slightly larger suiban).

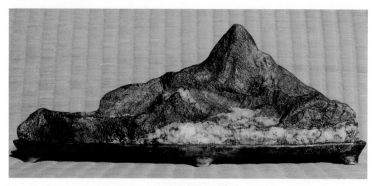

Fig. 39. Distant mountain stone suggesting a mountain with a single peak. Height: approx. 4 inches (10 cm.). Place of origin: Japan.

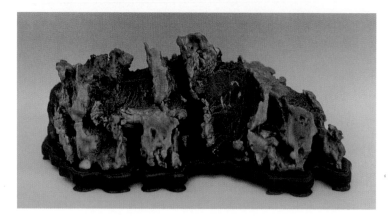

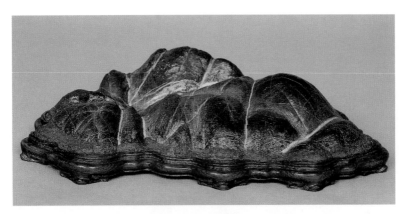

Fig. 41. An excellent example of a Thread-waterfall stone. Height: approx. 3 inches (8 cm.). Place of origin: Japan (Furuya, Wakayama).

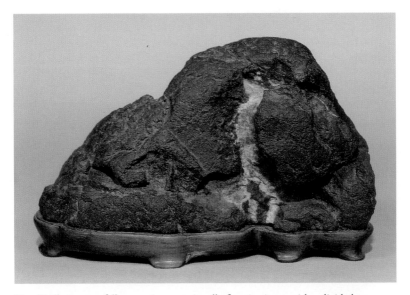

Fig. 42. Sheet-waterfall stone. An exceptionally fine specimen with a divided waterfall. Height: approx. 4½ inches (11 cm.). Place of origin: Japan (Kibune, Kyoto).

(Facing Page)
Fig. 40. Near-view mountain stone suggesting a jagged and steep mountain range. Height: approx. 7 inches (18 cm). Place of origin: United States (Mojave Desert, California).

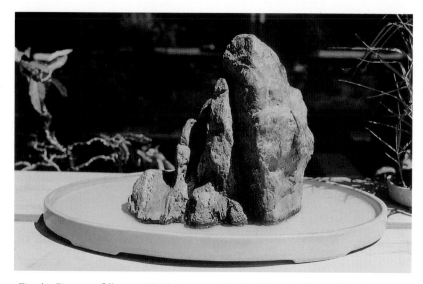

Fig. 43. Dry waterfall stone. Height: approx. 9 inches (23 cm.). Place of origin: Japan. (A more refined placement of the stone would be off-center to the right side of the suiban.)

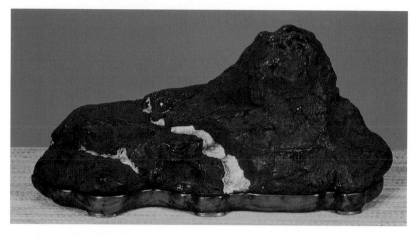

Fig. 44. Mountain-stream stone, one of six suiseki in the collection of the U.S. National Arboretum. Height: approx. 8 inches (20 cm.). Place of origin: Japan (Kibune, Kyoto).

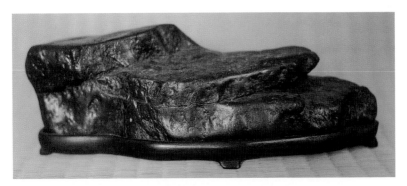

Fig. 45. Plateau stone. A fine example of its type, having three steps that vary in length. Height: approx. 4 inches (10 cm.). Place of origin: Japan.

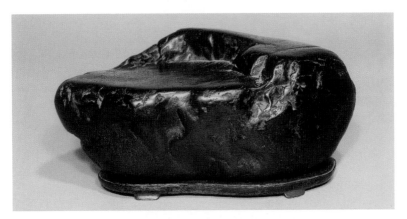

Fig. 46. Plateau stone. Note the fine black color. Height: approx. 4 inches (10 cm.). Place of origin: Japan (Kamuikotan, Hokkaido). (A deeper and darker dai with straighter legs would make the entire display more refined.)

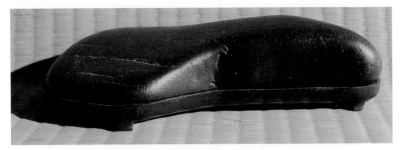

Fig. 47. Slope stone. Height: approx. 3 inches (8 cm.). Place of origin: Japan.

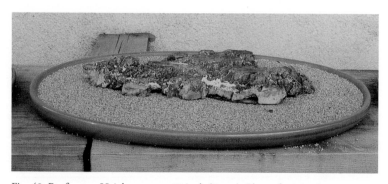

Fig. 48. Reef stone. Height: approx. ¾ inch (2 cm.). Place of origin: Japan. (A more refined placement of the stone would be off-center to the right side of a slightly larger suiban).

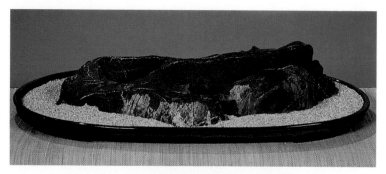

Fig. 49. Waterpool stone with several well-formed pools and caves, one of six su-iseki in the collection of the U.S. National Arboretum. Height: approx. 7 inches (18 cm.). Place of origin: Japan (Sajigawa, Tottori).

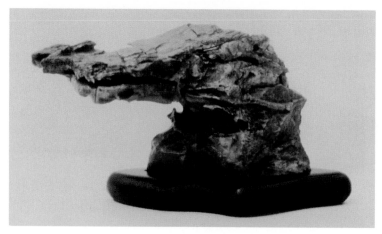

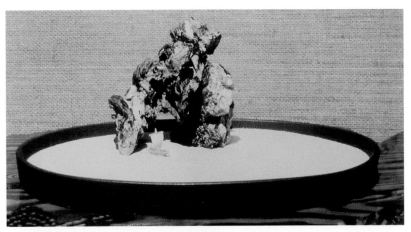

Fig. 51. Tunnel stone. Place of origin: Japan.

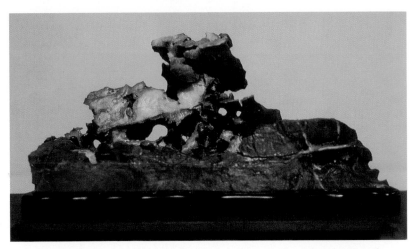

Fig. 52. Tunnel stone. Height: approx. 7 inches (18 cm.). Place of origin: United States (California).

(Facing Page)
Fig. 50. A fine example of a Shelter stone. Height: approx. 10 inches (25 cm.). Place of origin: United States (California. (Here, the dai extends too far beyond the stone and is thus distracting.)

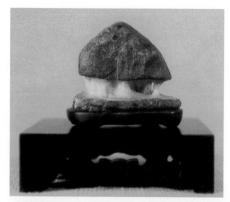

Fig. 53. A well-formed Thatched-hut stone. Place of origin: Japan (A table half the height would produce a feeling of greater stability in this display.)

Fig. 54. Thatched-hut stone poetically named "Birthplace." Place of origin: Japan. (A smaller table and a repositioning of the label to the side would improve the overall display.)

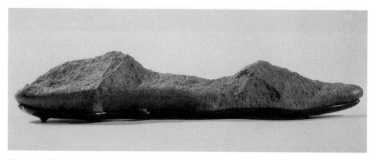

Fig. 55. Object stone. For some viewers the stone suggests an alligator. Place of origin: Japan.

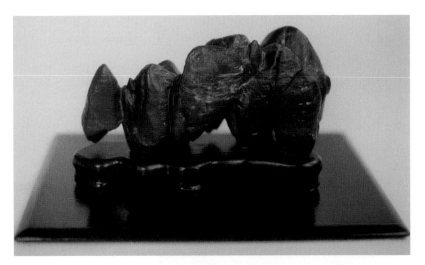

Fig. 56. Object stone suggesting an animal, perhaps a rhinoceros or a dinosaur. Also, the pass-through tunnel in the center of the stone suggests a natural arch. Height of stone: approx. 4 inches (10 cm.). Place of origin: Japan.

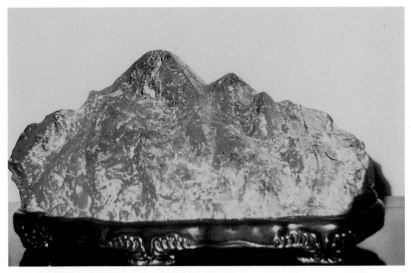

Fig. 57. Red stone. Place of origin: Japan (Sado Is.).

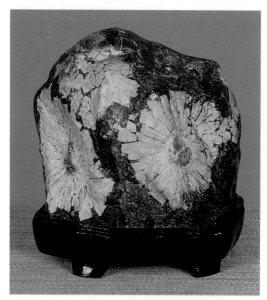

Fig. 58. Neodani chrysanthemum-pattern stone with the shape of a Coastal rock stone, one of six suiseki in the collection of the U.S. National Arboretum. Height: approx. 10 inches (25 cm.). Place of origin: Japan (Neodani, Gifu).

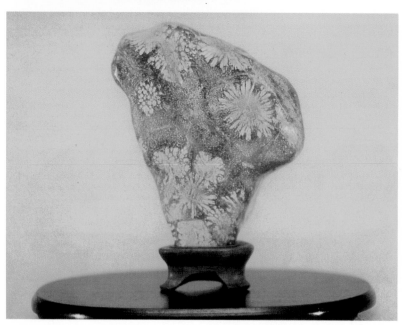

Fig. 59. Biseki. A highly polished and carved Chrysanthemum-pattern stone. Place of origin: Japan.

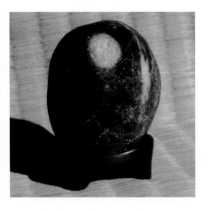

Fig. 60. Moon-pattern stone. Height: approx. 2 inches (5 cm.). Place of origin: Japan.

Fig. 61. Tiger-stripe-pattern stone. Height: approx. 9 inches (23 cm.). Place of origin: Canada (British Columbia).

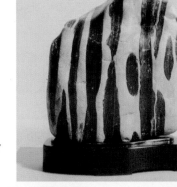

Fig. 62. Pit-marked Snake-pattern stone suggesting a distant mountain. The sinuous furrows in the center section and the pit marks along the side contribute to the stone's textural beauty. Height: approx. 6½ inches (17 cm.). Place of origin: Japan (Tadami-gawa, Fukushima).

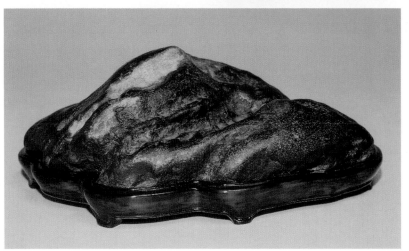

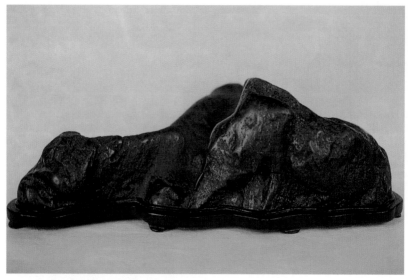

Fig. 63. Nachiguro stone with the shape of a Distant mountain stone. Height: approx. 7 inches (18 cm.). Place of origin: Japan (Nachiguro, Wakayama).

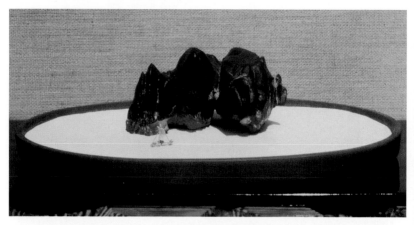

Fig. 64. Furuya stone with the shape of a Coastal rock stone. Place of origin: Japan (Furuya, Wakayama). (A more refined placement of the stone would be off-center to the right side of the suiban. Further, the bright white sand is distracting and might be replaced with off-white or beige sand.)

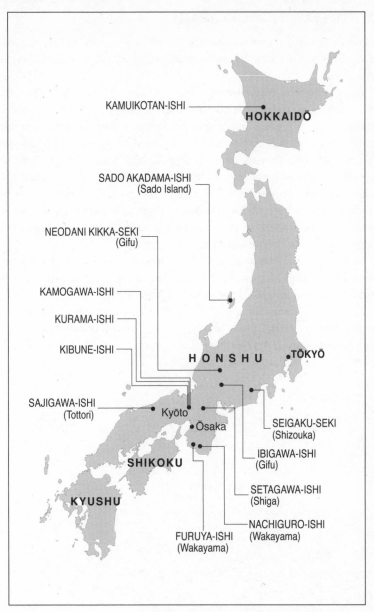

Map of Japan showing major suiseki collection sites.

OTHER CLASSIFICATORY TERMS

In addition to the classificatory terms already noted, several specialized terms are used by Japanese collectors to classify particular types of stones.

BISEKI (lit., beautiful stones): These are not strictly suiseki, but are often displayed together with suiseki at exhibitions. *Biseki* are stones that have been carved or polished to enhance their beauty. Japanese collectors prefer stones that have been carved or polished to bring out an embedded flower pattern or to deepen the stone's color. In contrast to suiseki, biseki do not have to have a suggestive shape (Fig. 59).

MEISEKI (lit., famous stones): This is the term used for suiseki or biseki that have become famous due to their outstanding qualities and beauty. Many of these stones have been passed down from generation to generation for several hundred years (see Fig. 3).

YURAISEKI (lit., historical stones): Suiseki or biseki that have been owned by famous historical persons or that are associated with notable historical events are called *yuraiseki* (see Figs. 4, 28).

REIHEKI (lit., steep cliff spirit): These are Chinese stones characterized by their sharp vertical lines, highly eroded surfaces, convoluted forms, and pass-through holes (see Fig. 2).

CHAPTER 4

Displaying the Stone

A suiseki that is poorly displayed loses much of its beauty and suggestive power. As a result, collectors take great care in choosing an appropriate container and in creating a beautiful display area. Reflecting these areas of concern, this chapter is divided into two parts. The first part describes different types of suiseki containers, while the second discusses the creation of a display area.

CHOOSING A CONTAINER

Aside from placing a suiseki in a tray containing plants and other materials (a practice to be discussed in Chapter 5), there are two traditional ways of exhibiting a suiseki: on a *dai* (sometimes referred to as a *sekidai),* a wooden base carved to fit the stone; or in a *suiban,* a shallow watertight container filled with sand, water, or both (Fig. 65). Some collectors will exhibit the same suiseki in a suiban in summer to suggest coolness, and on a dai in winter. In either instance the container should not detract from the stone; the suiseki always takes precedence over the container.

A dai is traditionally dark in color. The wood either has a natural finish or it is covered with black, brown, reddish-brown, or clear lacquer. Carved to follow the exact lines of the stone, a typical dai has a narrow lip and short legs. If the base of the stone is irregular or uneven, the interior of the dai is often carved out until the stone can be firmly seated. Appendix I (p. 142) provides a detailed description of the carving process, as well as a description of the woods, styles, dimensions, and finishes used.

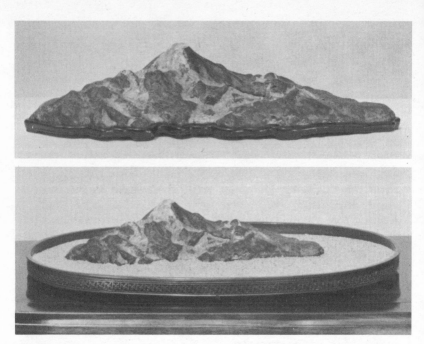

Fig. 65. (a) Distant mountain stone set on a dai. (b) Same stone set in a bronze suiban.

Suiban come in a variety of colors. Most suiseki collectors prefer suiban that are pastel or neutral in color (especially shades of gray, beige, or tan), since these shades are less likely to detract from the color of the suiseki. If a brightly colored suiban is used, it should complement, not compete with, the color of the suiseki. A bright red suiban, for example, would not be appropriate for a predominantly red-colored stone.

Traditionally, suiban have short squat legs, are rectangular or oval in shape, and are made of glazed or unglazed earthenware or ceramic. For exhibiting fine or delicate suiseki, some collectors use a watertight bronze or copper tray (known technically as a *doban)* that has been allowed to develop a gray-green patina. In areas where suiban are not commercially available, shallow oval or rectangular bonsai trays are often suitable, especially if the drainage holes are plugged with a waterproof compound.

Suiban vary widely in length and width, although they are typically 16 to 18 inches long and 10 to 13 inches wide. On average, a typical

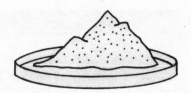

(a) Poor choice: suiban too small for suiseki

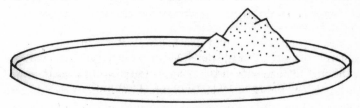

(b) Poor choice: suiban too large for suiseki

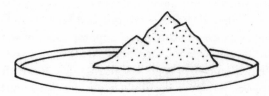

(c) Good choice: suiban approximately twice the size of suiseki

66. Relationship between size of suiban and suiseki.

suiban is twice the length of the suiseki (Fig. 66). If the suiban is too long or wide for the stone, some collectors will fill the excess space with a miniature accessory, such as a cottage, sailboat, or human figurine.

The depth of a suiban ranges between ½ inch and 1½ inches. The average ratio of the height of the suiban to the height of the suiseki is about 1:4 or 1:5, with the ratio for different displays varying between 1:2 and 1:7. In general, suiban for flat, smooth, or delicate suiseki tend to be shallower than suiban for rough, heavy, massive, or tall suiseki.

Aside from the suiban's color, height, and length, the style and shape of the lips, legs, and sides also need to be considered. Different styles and shapes vary considerably in their visual impact, and this must be taken into account in choosing a suiban (Figs. 67-70). Visually powerful suiban are generally appropriate only for visually powerful suiseki.

Fig 67. A shallow, oval-shaped ceramic suiban with straight sides and simple lines, suitable for a smooth and delicate suiseki.

An example of a powerful suiseki would be a rugged and massive Near-view mountain stone with rough textures and forceful lines. A visually powerful suiban would have one or more of the following characteristics: wide and flaring lips; decorated side panels (with the design inset or in relief); squared-off corners; straight, highly convex, or highly concave sides; substantial depth; and complex or heavy legs. A soft and delicate suiseki, with smooth textures and rounded lines, would probably be overwhelmed by such a suiban. A more appropriate suiban would be one that is shallow and oval in shape, with a narrow lip or no lip at all, with plain, slightly convex or slightly concave sides, and with plain or inconspicuous legs. If there is any doubt about the visual impact of the suiseki, it is usually best to choose a simple, unadorned suiban.

The suiban is traditionally filled with sand and water. Most collectors level and smooth the sand using feathers, spoons, or other tools. Alternatively, the sand can be smoothed by (1) filling the suiban with sand and water, (2) shaking the suiban back and forth until the sand is flat, and (3) removing the excess water by carefully tilting the suiban. Fresh water can then be poured into the suiban from behind the suiseki. When the stone is exhibited, the height of the water above the level of the sand should be approximately ¼ inch (Fig. 71).

Most collectors use only off-white or beige sand, as pure white sand is considered too bright (see Fig. 64). Sands of different levels of fineness are used, ranging between screen-mesh 24 and 14 lines per inch. The sand is always carefully sieved and washed before display. Fine-grained sand is generally employed with smoother or smaller suiseki, while more coarsely grained sand is used with roughly textured or larger suiseki. These are only crude guidelines, however, and the exact color and texture of the sand will depend on what best complements the stone.

Fig. 68. A shallow, oval-shaped ceramic suiban with straight sides and a heavy rim, suitable for a heavy stone with both rough and smooth surfaces.

Fig. 69. A shallow, oval-shaped bronze suiban with straight sides and silver-inlaid panels, suitable for a suiseki with rough texture or complex surface patterns.

Fig. 70. A deep, rectangular-shaped ceramic suiban with straight sides and thick walls, suitable for a rugged and powerful suiseki.

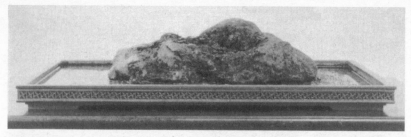

Fig. 71. Distant mountain stone set in a bronze suiban filled with sand and water. The elaborate design of the suiban harmonizes well with the rough texture of the stone.

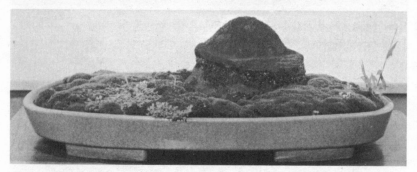

Fig. 72. Thatched-hut stone set in soil covered with moss and short grasses. The off-center placement of the stone is most appropriate.

Occasionally, a suiseki collector will omit the sand, filling the suiban with water only, especially if the bottom of the suiban is beautifully glazed (see Fig. 20). Even more rarely, some collectors will set the suiseki in a bed of soil covered with a blanket of moss or short grasses (Fig. 72). If soil is used, the suiban should have water-drainage holes; without these holes, the soil will become waterlogged.

In recent years the practice of using only sand in the suiban has substantially increased in popularity (Figs. 105, 106). However, many traditionalists criticize this trend, arguing that the full power of a suiseki can only be brought out by placing the stone in a water setting. Apart from the symbolic importance of water (as a nourishing and restorative substance), its fluidity, softness, wetness, and reflective qualities effectively balance the solidity, hardness, and dryness of the stone.

The proper positioning of the suiseki in the suiban is of great importance. The stone should appear to be anchored or deeply buried,

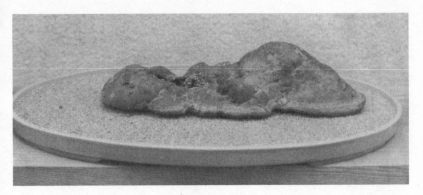

Fig. 73. Weak stone placement: the suiseki is apparently floating on the sand in the suiban; the stone should be buried more deeply.

not floating or sitting on the surface (Fig. 73). The stone should also be set off-center and slightly behind an imaginary horizontal line running through the middle of the suiban. Although no absolute rules have been established—the exercise of good aesthetic judgment being the dominant factor—the center of the suiseki is typically placed about sixty percent of the distance from either the left or right side of the suiban, with ample room left between the stone and all edges of the container (see Fig. 66). If the stone is angled to the right or if the highest peak is on the left side, the stone is placed on the left side of the suiban (the open space at the opposite side of the basin is sometimes referred to as an "eye-resting area"). Conversely, if the stone is angled to the left or if the highest peak is on the right side, the stone is placed on the right side of the suiban (Fig. 74). Whatever the final placement, most suiseki are tilted slightly forward in the direction of the viewer.

Miniature accessories—such as miniature houses, boats, bridges, animals, or human figurines—are seldom used with a suiseki. Such accessories are frequently out of scale with the scene suggested by the stone. Morover, they can limit the suggestive possibilities of the suiseki. A miniature boat placed in a suiban containing sand and a Mountain stone, for instance, forces the viewer to see an island; without such an addition, some viewers may see a mountain thrusting its summit through a thick layer of clouds or a peak rising above a field of ice. This does not mean that miniature accessories should never be used. However, they should be placed as inconspicuously as possible and used

(a) Weak placement: left side of suiban

(b) Weak placement: center of suiban

(c) Good placement: right side of suiban

74. Placement in the suiban of a stone whose right side is higher than its left.

primarily to accent or emphasize strong points of the suiseki. Also, they should be in scale, they should be of the finest workmanship and quality (some of the best being made of bronze or copper), and they should be employed with great discretion. If care is exercised, a well-chosen miniature accessory can heighten the viewer's appreciation of the suiseki (Figs. 75, 107).

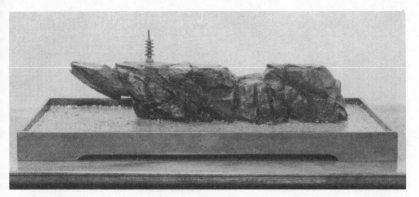

Fig. 75. Island stone with a finely crafted bronze miniature pagoda enhancing the atmosphere of the display.

CREATING A DISPLAY AREA

The display alcove

When exhibited in a Japanese style display area, a suiseki is almost always accompanied by another work of art, such as a bonsai, a Japanese flower arrangement, a fine ceramic or lacquer piece, a planter containing grasses, an incense burner, or a hanging scroll. These objects are traditionally placed in a *tokonoma*—a recessed alcove 3 feet deep, 6 to 9 feet long, and approximately 4 inches above floor level. The surface of the tokonoma is covered either with polished wood or with a *tatami,* a mat made of rice straw and woven reeds. When displayed in the tokonoma, each individual object is typically placed on a wooden table or stand with its most attractive side facing toward the viewer (Figs. 76-78).

On the back wall of the tokonoma, a hanging scroll is traditionally hung in the exact center, with the principal display piece directly in front or to the side of the scroll. The subject of the scroll is usually a poem written in Japanese calligraphy or a landscape painting that is closely related to the suiseki and the other objects on display. The scroll and art objects should complement, not duplicate, one another. When viewed as a group, the objects should form a simple, serene, and harmonious whole, suitable to the season in which the objects are displayed.

Many Western collectors substitute a photograph, drawing, or print for the traditional Japanese scroll. In recent years some collectors have

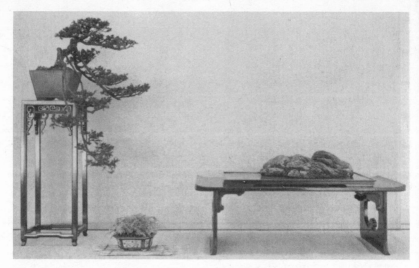

Fig. 76. Distant mountain stone displayed with an Ezo spruce bonsai and a planter containing ferns. The placement of the art objects is excellent; each one occupies one point of a balanced asymmetrical triangle.

also experimented with incense, soft music, and colored lighting to enhance the suggestive atmosphere.

In Western style rooms containing Western style furniture, a display area can be created on shelves or on a table set in a corner. The height of the display area is usually at least 2 feet above the floor. A plain off-white or beige wall is the most effective background, although an unpatterned off-white, beige, gray, gold, or silver curtain or flat screen can also be used. Lighting should come from above and in front, so as not to cast shadows.

Tables and other types of stands
The most attractive tables are made of polished teak, rosewood, or other fine wood, with legs that are either straight or curved (Fig. 79). The exact height of the table is determined by the art object's height and shape. Mountain and Waterfall stones, as well as objects that have a strong vertical orientation, generally look best on medium-high or high tables. Plateau and Slope stones, as well as objects that have a strong diagonal orientation (such as slanting style bonsai), generally look best on low to medium-high tables. Shore, Island, Coastal rock,

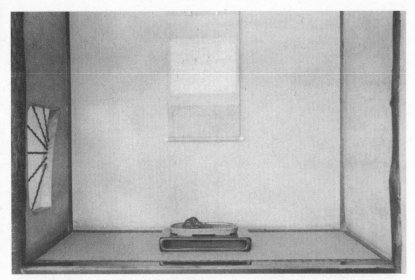

Fig. 77. Distant mountain stone displayed with a hanging scroll in a tokonoma. The placement of the suiseki in the exact center of the tokonoma creates a formal atmosphere.

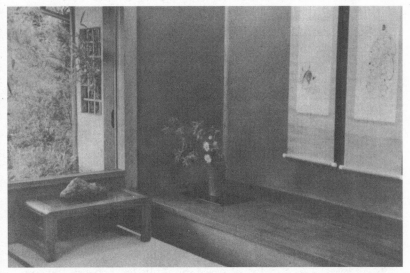

Fig. 78 Distant mountain stone, set on a low table, used with a Japanese chrysanthe-mum flower-arrangement and two hanging scrolls in the interior design of a Japanese style room. The bamboo outside the window suggests a bamboo grove and forms an interesting background for the suiseki.

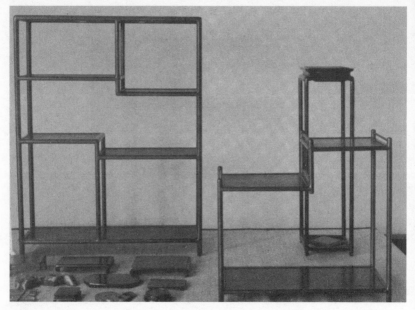

Fig. 79. Various stands used for displaying suiseki and other art objects.

and Waterpool stones, as well as objects that have a strong horizontal orientation, generally look best on low tables. As a rule of thumb, the table is seldom greater than one and a half times the height of the subject. For stability, however, exceptionally tall suiseki tend to be set on low tables.

The shape of the table—oval, rectangular, or irregular—should be closely related to the shape of the art object and its container. Similarly, the visual power of the table, determined by its visual heaviness and by the complexity of its design, should be in harmony with the visual power of the object. For example, a heavy and rugged object—such as a Near-view mountain stone—set in a heavy rectangular container might suitably be placed on a visually powerful rectangular table. As a general principle, the greater the visual impact of the art object, the heavier the feeling of the table and the thicker the wood and legs (Fig. 80).

In all cases, 2 to 4 inches of space should be left between the container and the edges of the table. To protect the finish of the table, a piece of glass, a sheet of clear plastic, or a neutral-colored pad, mat, or cloth is often placed between the container and the table.

Fig. 80. A rugged Mountain stone set on a sturdy rectangular table. Since the suiseki is the focal point of the display, it is raised higher than the companion piece, a five-needle pine bonsai. The suggestion of alpine scenery is enhanced by the bonsai—a high-altitude species—and by the higher placement of the stone.

In addition to tables, collectors use a variety of other types of stands to display suiseki, including polished tree stumps (with flat tops and with gnarled roots for legs), rectangular boards (either lacquered or well seasoned), stone slabs, rafts made of bamboo canes or reeds (tied together with raffia or hemp cord), and natural or carved wooden boards made of polished tree burl or driftwood. Some collectors prefer the simplicity of a flat cherry, pine, or hemlock board, ½ to 1 inch thick, that has been lightly burnt with a torch, washed and scrubbed with a wire brush, and then painted with clear lacquer. However, the stand should never detract from the suiseki or its container; the suiseki always takes precedence over the stand (Fig. 81).

Miniature suiseki and art objects less than 3 inches tall require special stands. The objects are usually arranged as a group and are displayed on stands with tiered or staggered shelves (Fig. 82). The location of objects on each shelf should be consistent with their location in a natural environment. As a result, Waterpool, Island, Coastal rock, Shore, and Thatched-hut stones, as well as bonsai common to lowland areas and planters containing grasses, are generally placed on the lower shelves; whereas Distant mountain stones and bonsai trees commonly found in upland areas are generally placed on the upper shelves.

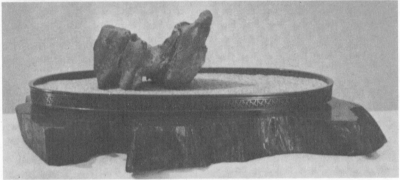

Fig. 81. Poor choices of stands: (a) The suiseki is overpowered by the heavy, elaborate table. A simple and sturdy table one-third the height of the one used would be more refined, (b) The same suiseki is in this instance overpowered by a thick board made of polished tree burl. A board one-third the height would be more complementary.

Designing and arranging the display area

The creation of a beautiful display area requires considerable thought and attention. It is essential that one object be clearly identifiable as the focal point or principal subject of the display (Fig. 83). The subject and shape of the companion pieces should be chosen to complement and enhance the principal object. Emphasis can be added by placing the principal object on a higher stand (Fig. 84). Other objects can also be placed on stands, but these should be lower in height. To further enhance the beauty of the principal object, the total number of objects

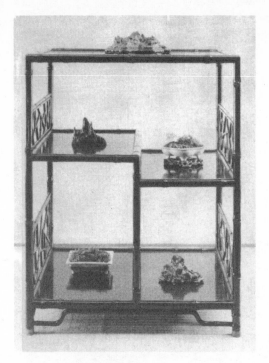

Fig. 82. Arrangement of miniature suiseki and planters on a stand with staggered shelves.

on display should be kept to a minimum. Displays that include more than three objects often appear cluttered.

The color of the stands, containers, and companion pieces should complement the principal object. A dark purple suiseki, for example, will often be displayed with art objects, containers, and stands that are green, red, yellow, black, gray-brown, or neutral in color. Interest is added to the display by selecting objects that do not exactly repeat the same colors. The arrangement can also be enhanced by varying the texture, shape, size, and height of all objects set in the display area. A smooth-textured suiseki, for instance, might look best placed next to a finely detailed art object. The slant of the objects, the distance between them, and the shape of the stands should also vary.

A generous amount of space should be left between the edge of the tokonoma or display area and the objects. Sufficient space should also be left between the objects themselves, and between the bottom of the scroll and the top of the art objects. With one exception, the principal

Fig. 83. A poorly designed display area. The Shelter stone, incense container, and hanging scroll each compete with one another for attention; none is clearly identifiable as the focal point of the display.

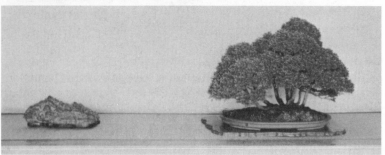

Fig. 84. A weak display. The Mountain stone and Ezo spruce, set at the same level, compete for attention. The display could be refined by placing the suiseki on a low table.

object of the display is traditionally placed off-center, approximately one-third the distance from the edge of the display area, and slightly behind an imaginary horizontal line running through the middle of the space (Fig. 85). The exception occurs when the principal subject is particularly stable in appearance, when it conveys almost no sense of horizontal movement, or when the intention is to emphasize its beauty. In such cases the object is placed in the center of the display area

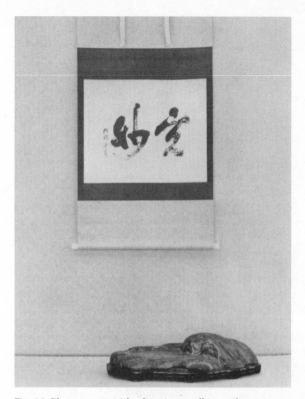

Fig. 85. Plateau stone with a hanging scroll in a tokonoma.
The design of the display area is simple and elegant. Since the
high point of the suiseki is on the right, the stone is placed to
the right, approximately one-third the distance from the edge
of the alcove.

with the hanging scroll set directly behind it (Fig. 86; see Fig. 77). If
two objects are set in the display area, one should be set back from the
other; they should not be arranged in a line parallel to the edge of the
display area. If three objects are placed in the display area, they should
be arranged to form an asymmetrical triangle (from both an aerial and
frontal view). When viewed from the front, the terminal or highest
point of each object should form one corner of the triangle, with the
highest point of the principal subject elevated to form the peak of true
triangle. The top of the scroll, the edge of a stand, or the edge of the
display area can also function as one corner of the triangle.

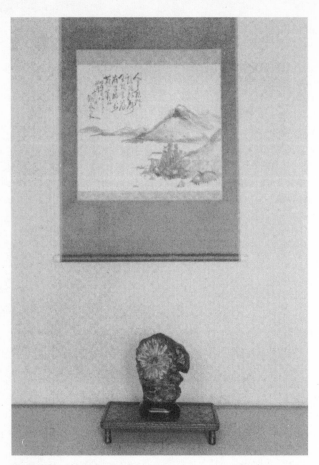

Fig. 86. Neodani chrysanthemum-pattern stone with a hanging scroll in a tokonoma. The stone conveys almost no sense of horizontal movement and is thus placed in the exact center of the display area. The suiseki and the subject of the scroll, a small house built on the shore of a mountain lake, beautifully complement one another.

Combining art objects

A major consideration in combining art objects is the degree of intended formality. Three levels of formality are traditionally distinguished by Japanese collectors: formal *(shin)*, semiformal *(gyo)*, and informal *(so)*. The formal style of display is characterized by the greatest verticality,

symmetry, straightness of line, and decorum. As a result, the classic suiseki—the Distant mountain stone—is best suited for formal style displays. Since the concept of formality also encompasses the containers, stands, and other objects in the display area, the emphasis should also be on verticality, symmetry, straightness of line, and subdued or neutral colors (see Figs. 77, 86). Antique Chinese containers and stands have traditionally been considered appropriate for formal displays.

The semiformal style of display is characterized by greater horizontality, asymmetry, softness of line, and curvacious form. Appropriate suiseki for this style are Slope and Plateau stones. For semiformal displays, art objects with soft contours and slanted or curved lines, as well as rounded or oval containers and stands, are preferred (see Fig. 85).

The informal style of display is characterized by the greatest horizontality, asymmetry, irregularity, flexibility, casualness, delicacy, and softness. Suiseki most suited to this style are Waterpool, Thatched-hut, Pattern, and softly contoured Slope or Distant mountain stones, especially when set next to a planter containing sweet rush (sweet flag or acorus), dwarf pampas-grass, dwarf bamboo, or other grasses (see Fig. 108). Suiseki that are humorous or playful are also appropriate. For informal displays, the art objects, containers, and stands can be elaborate and colorful or quite simple.

Season

When selecting objects for the display area, it is customary to consider the symbolic and seasonal significance of the objects (Fig. 108). In winter, and especially during the New Year holidays, the Japanese traditionally display objects that symbolize or represent the "three friends of winter"—pine, bamboo, and Japanese plum blossoms. The pine, green all year and clinging with all its power to a rock face or cliff, symbolizes long life. The bamboo, because of its flexibility and its ability to bend without breaking, symbolizes strength and endurance. Japanese plum blossoms, which appear when the ground is still covered with snow, symbolize courage and nobility. These three items, when represented by a Pattern, Object, or Color stone combined with a scroll or the plants themselves, convey the host's wishes for good fortune in the new year.

In the spring, summer, and autumn, the following subjects are especially popular in Japan: Japanese plum blossoms, wisteria, forsythia, and cherry blossoms in early spring; azalea, iris, and peony in late spring;

lotus, bush clover, pomegranate, weeping willow, morning glory, green grasses, waterfalls, and mountain lakes in summer; chrysanthemum, persimmon, red maple leaves, berries, flowering pampas-grass, and the harvest moon in autumn.

Harmony of the overall design

Figure 108 illustrates how some of the factors described above are applied in practice. In this sparse and deceptively simple asymmetrical arrangement of only two subjects, the focal point is a Distant mountain stone. Each element in the arrangement reinforces and enhances the seasonal theme of the display: a peaceful summer day in the country. The planter containing grasses in the foreground set on a flat, thin, irregularly shaped piece of wood suggests the green fields of summer; the suiban filled with water and sand suggests a cool mountain lake; the high table in the background heightens the illusion of a high distant mountain; the yellow color of the suiban recalls the warm colors of summer; and the simple, smooth, soft, and rounded lines of the containers, stands, and art objects heighten the sense of calm and tranquillity.

CHAPTER 5

Suiseki with Bonsai and Other Related Arts

Bonsai (lit.: *bon*, tray; *sai*, to plant) are naturally or artificially dwarfed trees trained to grow into beautiful shapes. We have already seen that in Japan suiseki are traditionally displayed in a tokonoma with other art objects, including bonsai (see p. 75). Aside from this practice, suiseki and bonsai may be combined into a single, unified work of art.

This is done in two basic ways. First, a rock planting, or *ishi-tsuki* (lit.: *ishi*, stone; *tsuki*, attached to), can be made by planting the bonsai directly onto the suiseki (Fig. 87). Second, a tray landscape, or *bonkei* (lit.: *bon*, tray; *kei*, scenery),[8] can be made by arranging one or more suiseki and bonsai in a suiban filled with water (Fig. 113).

GENERAL CONSIDERATIONS

When suiseki are combined with bonsai, either as a rock planting or as a tray landscape, both take on additional life and beauty. Moreover, the marriage of tree and stone can be advantageous for both the bonsai and the suiseki enthusiast. For the bonsai artist, young trees only a few years old can be planted on or with a suiseki and enjoyed almost immediately. In contrast, the creation of a fully mature and presentable bonsai planted in its own container can take a lifetime. For the suiseki collector, a defect in an otherwise good suiseki can be hidden by attaching a bonsai, by partially burying the suiseki in soil, or by concealing the undesirable part under moss or grass. Soil can also be used to stabilize a stone with an uneven bottom.

8. The bonsai literature sometimes uses the term saikei (lit., sai, to plant; kei, scenery)—also translated as "tray landscape"—rather than bonkei. While saikei is currently popular among Western enthusiasts, in this book we use the original and more traditional term bonkei. The word saikei was coined in 1963 by the tray-landscape artist and author Toshio Kawamoto, and is a registered name belonging to him.

Fig. 87. Rock planting (root-over-rock style): a trident maple with well-formed roots on a rough-textured Shelter stone.

Combinations of suiseki and bonsai

In designing a rock planting or tray landscape, the suiseki and bonsai should be in harmony, each evoking and enhancing the feeling, movement, and aesthetic qualities of the other. For guidance it is helpful to follow nature. In general, suiseki and bonsai can effectively be combined if the type of suiseki and tree are found together in a natural environment. Coniferous trees—such as pine, juniper, hemlock, certain varieties of spruce, and larch—often grow on steep mountain slopes or on cliff edges. Because of their tolerance for dry and poor soils, they also grow well in rocky or sandy regions, such as those found on some islands. Deciduous trees— such as maple, oak, beech, and hornbeam— grow well on upland slopes and in the rich, moist soil of valleys, and are often found among large boulders. Finally, lowland trees such as willow and bald cypress often grow well near water or at the bottom of a valley and are often seen in the vicinity of highly eroded flat stones. Several combinations of bonsai and suiseki are suggested by these observations: coniferous bonsai with Mountain, Water-fall, Cave, Coastal rock, and Island stones; deciduous bonsai with Mountain, Mountain-stream, Plateau, Shelter, and Slope stones; willow and bald cypress bonsai with

Fig. 88. Thatched-hut stone with an Ezo spruce bonsai.

Waterpool, Shore, and Thatched-hut stones. Thatched-hut stones are in fact suitable companion pieces for virtually any type of bonsai (Fig. 88). All the combinations noted above would be equally appropriate for suiseki and bonsai displayed individually in a tokonoma.

For maximum effect, the suiseki and bonsai should capture the spirit of their full-size counterparts. The best suiseki are those that suggest the forms of nature with a minimum of detail. The best bonsai are those that suggest the natural characteristics of the full-sized tree. Bonsai fitting this description usually have small leaves, needles, flowers, and fruits; a tapered trunk and attractive bark that gives the impression of age; thick foliage growing in dense clusters; and branches that are in balance and in scale with the size of the tree.

Bonsai can be styled in several different shapes through pruning, trimming, and wiring. Most of these styles are variations on five basic shapes: formal upright, informal upright, slanting, semi-cascade, and cascade (Figs. 89-93). These styles are based on the angle at which the trunk slants away from the vertical. Needle evergreen trees can be planted in any of these five styles. Other species (broadleaf evergreen trees, deciduous trees, and flowering trees) are usually not created in the formal upright style, although other styles are appropriate. Another major

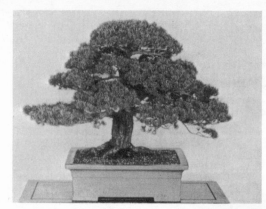

Fig. 89. Formal upright style. Bonsai species: Japanese white pine.

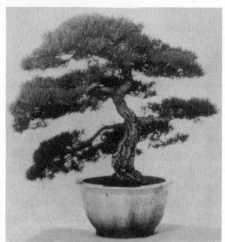

Fig. 90. Informal upright style. Bonsai species: Japanese red pine.

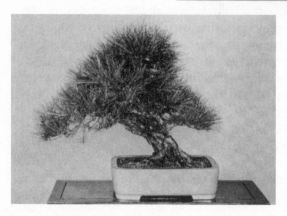

Fig. 91. Slanting style. Bonsai species: Japanese black pine.

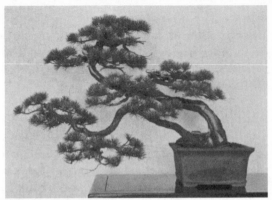

Fig. 92. Semi-cascade style. Bonsai species: Japanese five-needle pine.

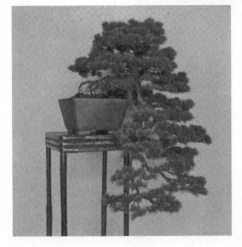

Fig. 93. Cascade style. Bonsai species: Japanese five-needle pine.

style is the multiple-trunk style (Fig. 109) in which several trunks rise from a common root system. Except for plants with a double trunk, most bonsai artists prefer those with an uneven number of trunks divided at the base in a V shape. Ideally, the trees should vary in height and thickness, with the trunk of the main tree somewhat heavier and taller than the others. The multiple-trunk style is especially useful and popular, since it is easier to maintain than individual bonsai plantings.

An observer viewing the finished bonsai should be presented with a clear, unobstructed, and attractive view of the tree's structure, including the trunk, branches, and exposed roots. Starting about one third up the trunk, the branches should grow out to the side and to the back;

they should not cross one another or point directly at the viewer. At least one of the lowest branches should reach toward the back, giving depth to the tree. The apex of the tree should lean slightly toward the viewer, except in the formal upright style, in which it lies directly above the base of the tree.

Selecting an appropriate container

The container is crucial to the overall success of the composition. Like the frame for a painting, it should show the subject to its greatest advantage. Containers made of earthenware or ceramic tend to be preferred, although containers made of cement, preserved wood, bronze, and copper are used in special circumstances. The color of the container should not compete with the color of the suiseki or with the color of the bonsai. Most collectors prefer neutral colors (beige and off-white), subdued natural earth tones (dark brown, dark red, dark green, and gray), or pastels, since these colors work well with the color of most suiseki and bonsai. Brightly colored containers are less frequently employed, since they can be distracting and may overpower the main subject.

Rock-planting and tray-landscape containers are seldom more than 2 inches deep. The depth of the container is closely related to its width and length. As a general rule, the longer and wider the container, the greater its depth. Rock plantings and tray landscapes are usually easier to create in oval or rectangular containers, although containers also come in other shapes, including round, square, and hexagonal.

In recent years appropriate containers have become readily available outside Japan. They can be obtained from most garden supply houses, nurseries, import shops, and other stores that carry bonsai materials. They can also be ordered directly from supply firms that advertise in bonsai magazines.

Occasionally a rock planting will be set directly on a display stand without a container (see Fig. 94). In such cases a piece of glass, a sheet of clear plastic, or a cloth should be placed under the stone to protect the table.

ROCK PLANTINGS

Rock plantings are an effective and highly dramatic way of combining suiseki and bonsai (Figs. 94, 95). There are two basic styles:

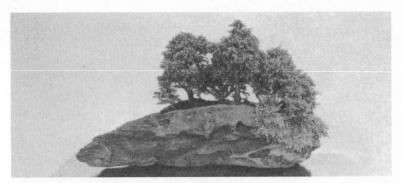

Fig. 94. Rock planting (clinging-to-a-rock style) suggesting the island scenery depicted in Figure 95. Bonsai species: dwarf cryptomeria.

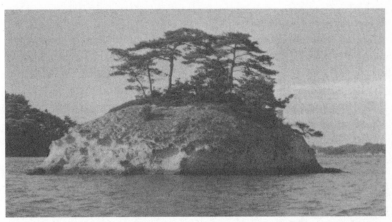

Fig. 95. A natural scene showing pine trees clinging to an island off the coast of Japan.

1. ROOT-OVER-ROCK STYLE: The roots of the tree are trained down over the stone and into a bed of soil (Figs. 96, 111; see Fig. 7). For adequate water drainage, the container should have two or more drainage holes that are at least ½ inch in diameter.

2. CLINGING-TO-A-ROCK STYLE: The bonsai is grown entirely on the stone, the roots being wholly contained within peat that has been pressed onto the stone (Figs. 97-101, 112; see Fig. 94). In this style of planting, a bed of soil is not required. Instead, the stone is typically placed in a shallow suiban filled with sand, water, or both.

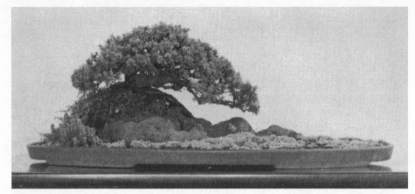

Fig. 96. Rock planting in the root-over-rock style: spruce and moss on Mountain stone.

Selecting appropriate suiseki

The best suiseki for rock plantings are those that have an abundance of natural crevices, irregular contours, fissures, weathered channels, and rough surfaces (see Fig. 87). Such stones hold pockets of soil well, and the crevices can be used to attach and guide roots or to hide wires anchoring the tree. The most suitable types of suiseki for rock plantings are Near-view mountain, Waterfall, Mountain-stream, Shelter, and Coastal rock stones. Other types of stones that lend themselves to this style of planting are Waterpool, Plateau, and roughly shaped Island stones. Larger suiseki are often reserved for rock plantings, while smaller suiseki are typically set aside for tray landscapes. If the suiseki cannot stand on its own, the base is usually cut flat, or several smaller stones are cemented to its base.

Selecting appropriate bonsai species

The most effective bonsai for rock plantings are trees that are mature; they do not, however, have to be fully grown. Seedlings and young trees two to five years old can be employed quite effectively, since the suiseki and other plants can be used to conceal flaws or to draw the viewer's attention away from aesthetically weak points. Dwarf varieties are particularly recommended, especially those with an abundance of long, thin, flexible, evenly spaced roots. Trees with inflexible roots are rarely used because it is difficult to flatten the roots against the surface of the stone. The tree should also be slow growing—thereby minimizing the need for transplanting—and should be able to endure dry or adverse

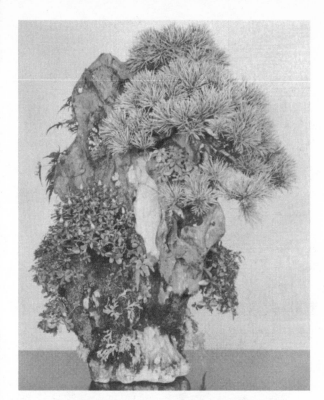

Fig. 97. Rock planting in the clinging-to-a-rock style: dwarf maple, five-needle pine, and dwarf azalea on Waterfall stone.

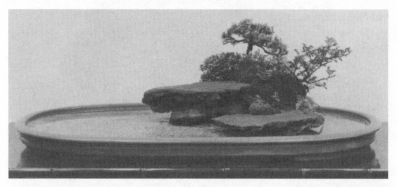

Fig. 98. Rock planting in the clinging-to-a-rock style: needle juniper, dwarf flowering quince, dwarf azalea, fern, and several varieties of ground cover on Plateau stone.

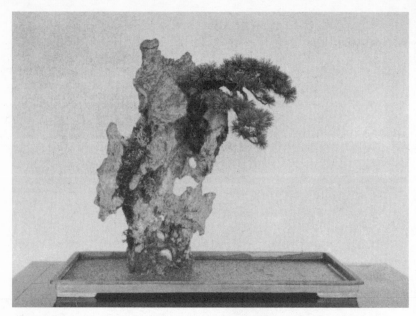

Fig. 99. Rock planting in the clinging-to-a-rock style: five-needle pine and fern on Tunnel stone.

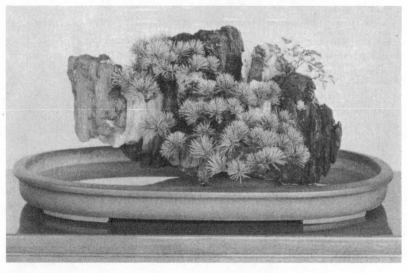

Fig. 100. Rock planting in the clinging-to-a-rock style: dwarf rose and five-needle pine on Coastal rock stone.

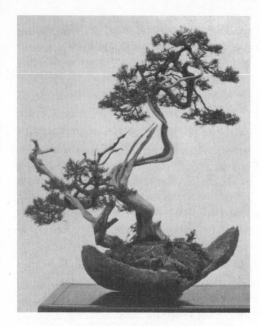

Fig. 101. Rock planting in the clinging-to-a-rock style: Sargent juniper and golden fern on Waterpool stone (in shape of a boat).

conditions. Pine (five needle, mugo, pitch, and black) and spruce are highly recommended, since they require little moisture and look attractive in a rock setting. Other recommended species are dwarf box, buttonwood, Japanese yew, Chinese juniper, needle juniper, hemlock, most varieties of cypress, and fir. Maple trees, especially trident maples, are excellent because their roots attach easily and mold themselves to the contours of the stone (see Fig. 87). Other suitable deciduous trees are elm and zelkova. Among fruit and flowering trees, the most suitable species are azalea, rock cotoneaster, English holly, fig, and gardenia. To encourage the growth of long feeder roots, plants collected directly from the wild should be planted for six months to one year in a deep pot or in the ground. When the branches, trunk, roots, and foliage fill out, the tree can be prepared for planting.

Selecting other plant material
For added color, interest, and a more natural appearance, as well as for holding the soil in place, several types of ground cover are suitable, including sedum, ferns, succulents, lichen, moss, and dwarf varieties of sweet-rush, horsetail (scouring rush or equisetum), bamboo, thyme,

veronica, mint, and saxifraga. Plants used for ground cover are often tightly grouped together to suggest wild shrubs and tree saplings.

Season

In general, rock plantings are best made just before new shoots begin to grow. Timing may vary, however, depending on the species. Since more soil is removed from the roots in a rock planting than in a typical bonsai transplanting, timing is especially critical for delicate species such as pine, spruce, and fir.

Design

The first step in creating a rock planting is to decide where on the suiseki to plant the bonsai. To help visualize this, the suiseki and bonsai are often placed on a revolving table, with the trees held in place by hand or lightly stuck to the suiseki with peat. As an additional aid, an artist will often draw a rough sketch of the proposed rock planting. In placing the bonsai, the eye movement suggested by the tree should be consistent with the eye movement suggested by the suiseki. Care should be taken to plant the main bonsai off-center, that is, either to the left or to the right of the suiseki's midpoint (see Figs. 97-100). It is also important not to choose a bonsai that is the same height as the suiseki.

When properly positioned, the suiseki and bonsai will form a unified whole, appearing harmoniously bonded (Fig. 110). If set correctly, neither the bonsai trunk nor the suiseki will interfere with a clear view of the other. The trunk of the bonsai will generally not jut out from behind the suiseki. Ideally, the base of the bonsai trunk will be visible from the viewing side, especially when only a single bonsai is used. The bonsai's foliage should be trimmed to cover, at most, only a small part—preferably the weakest feature—of the stone. To show stability, at least some roots should be trained down the front side of the stone. After the planting is completed, the stone should be placed slightly off-center toward the back of the tray.

Method

The circulation of air in the workplace should be minimized, since an airflow will quickly dehydrate roots, which should always be kept moist. All materials—container, suiseki, bonsai, grasses, moss, potting soil, anchoring wire, and tools—should be gathered together before

planting begins. Suiseki found near the seashore need to be soaked in fresh water for several months to remove the salt; otherwise the salt may damage or kill the plants (the only exceptions being plants that grow near the seashore, such as buttonwood). In addition to the items listed above, a quantity of peat muck should be prepared. The peat muck consists of finely sifted peat humus (screen-mesh 35 lines per inch), or, if available, finely sifted adobe mixed with 10 to 20 percent peat. It must be kneaded with water until it is sticky and the consistency of dough.

At the point on the stone where the tree is to be planted, a loop of copper wire (no. 20 Birmingham gauge) approximately 8 inches in length is fastened. The wire can be attached to the suiseki with fast-setting hydraulic cement or waterproof (marine) epoxy glue. In the United States and Canada several types of suitable water-stop cements and waterproof glues are commercially available. Alternatively, the wire can be wrapped around a small lead plug or sinker, which is then driven into a rock crevice with a chisel or punch. Drilling or chiseling a hole for the lead plug is generally not recommended, since this will permanently disfigure the suiseki. If the stone is lightweight and soft, it is also possible to hammer a short galvanized nail into the stone, wrapping the copper wire around the head of the nail.

The next step is to remove the soil carefully from the tree roots, either by loosening the soil with bamboo chopsticks or by washing. Until the tree is actually planted, the roots should be wrapped in wet newspaper or plastic held in place with a rubber band. In contrast to ordinary bonsai potting-techniques, the roots of the tree are not pruned.

A thin layer of peat muck is then smeared onto the stone where the roots of the tree are to be planted. The roots are carefully placed on the sticky peat and are laid in accordance with the aesthetic design of the planting. The most attractive crevices or cavities should not be filled with peat or roots, as such features enhance the beauty of the suiseki. The roots should then be covered with a layer of peat muck and tied down with the wires. After snipping off excess wire, the peat is firmly pressed down—with chopsticks or by hand—and molded to harmonize with the contours of the stone. Additional plants, if any, can be added in the same way.

The peat is then covered with pieces of live moss that have been dipped into water. If needed, the moss can be pinned in place either

with U-shaped lengths of copper wire, or with natural twine wound around the stone, or with cheesecloth. When twine is used, care should be taken not to tie it so tightly that it cuts into the roots. The natural twine does not need to be removed, since it will disintegrate on its own. The rock planting should then be gently watered through repeated spraying.

Procedures for handling bonsai roots differ for the clinging-to-a-rock style and for the root-over-rock style. In the former style, the roots are curled up inside the peat. The attached peat can easily fall off if disturbed, and the suiseki should be handled only where the bare rock is exposed or from the bottom. Since air is constantly circulating around the roots, regular soil changes are not needed. The bonsai should be removed from the stone only when tree growth upsets the balance of the arrangement. In root-over-rock style, the long roots are led down over the stone and distributed under and around the stone's base. If the roots are not long enough, a different suiseki may be needed. Alternatively, root growth can be encouraged by planting the bonsai in a deep container. For maximum root growth, the roots should not be pruned while the plant is in the container. A substitute method for promoting root growth is to partially bury the suiseki and bonsai together in a deep container filled with soil. After approximately two years, the roots will be long enough for the arrangement to be replanted in a suitable tray.

Prior to laying the roots in the root-over-rock style, peat muck should be worked into the stone's less attractive channels and crevices. The roots are then covered with peat muck and anchored to the stone with wire ties. If the ultimate intention is to develop and eventually expose root bark, the peat should be gradually removed after the root is heavy or mature enough to endure direct exposure to the air. This usually takes at least two years. Once the roots take hold, it will be extremely difficult to remove the bonsai from the suiseki.

After the roots are in place, the tray should be filled three-quarters high with bonsai potting-soil. The suiseki is set in the tray slightly toward the back and to one side, and should appear stable and deeply buried. Additional soil is then added, filling the tray. As with ordinary bonsai, soil is worked into the roots with chopsticks.

Care should be taken not to press the soil down too hard, as this inhibits air circulation around the roots. Excess soil is then brushed off, and a fine layer of soil, fresh or dried and powdered moss, small ferns,

grasses, or other delicate vegetation is added. To create an illusion of water, fine gravel or sand can be used to supplement or substitute for the moss and vegetation.

Arrangements in either the root-over-rock style or clinging-to-a-rock style need special care because the roots have been bared and the trees have been subjected to considerable stress. Especially during the first few weeks, the plants need to be kept moist and must not be exposed to direct sun, heavy rain, or strong wind. All parts of the arrangement need to be watered using a sprayer. Until new growth begins, it is often wise to keep the rock planting under a plastic tent. Fertilizer applications should be kept to a minimum, since a generously fertilized rock planting will grow too quickly. In a short time, rapid growth will throw the arrangement off balance.

TRAY LANDSCAPES

In a shallow tray filled with soil, the tray landscape artist arranges suiseki, bonsai, and other materials to suggest a scene from nature. The range of what might be created is limitless. The landscape can be made in the form of snow-capped peaks towering over valleys and forests, a quiet lake set deep in the mountains, a wild rocky coastline, a volcanic island with waterfalls and peaceful lagoons, a windblown tree perched high on a plateau, a desert butte in a pastel landscape, or a chain of rolling hills dotted with meadows and fields (Figs. 114-116, 123). For inspiration, the artist will sometimes refer to antique prints or drawings of classical tray landscapes (Fig. 102).

Selecting appropriate suiseki

Virtually any type of stone can be used in a tray landscape; however, suiseki with white markings that suggest water (such as waterfalls, cascading streams, or waves) are especially prized. If the design calls for a large number of stones, ordinary stones can be used to supplement the suiseki, especially if weaknesses in these stones are concealed with soil or groundcover plants. As with rock plantings, suiseki and other stones that are collected near salt water need to be thoroughly soaked in fresh water before being used. To add interest to the arrangement, the suiseki should vary in height and size; however, for unity and harmony the suiseki should have the same general texture, mineral composition, and color.

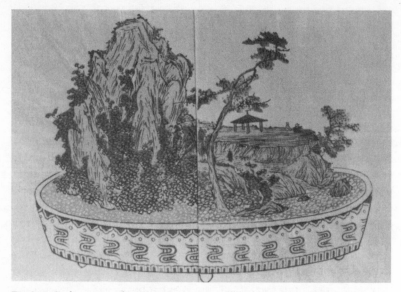

Fig. 102. Early nineteenth-century Japanese woodblock print showing tray-landscape design based on Chinese models.

When the tray landscape is especially large, the weight of the suiseki and other materials can be prohibitive. Under these conditions some tray-landscape artists prefer to use well-formed lightweight stones, such as sandstone, lava rock, or soft limestone (Fig. 103). However, many Japanese tray-landscape artists do not recommend such stones, since the texture is not appreciated and the stones cannot be expected to last for more than fifty years before breaking up.

Selecting appropriate bonsai

Almost any species of bonsai can be used in a tray landscape, but not always in the same arrangement. The only bonsai that are not appropriate are those with overly large needles, leaves, fruits, or flowers, such as podocarpus, avocado, dogwood, lemon, and hibiscus. These bonsai will generally appear out of proportion. For best effect, the bonsai should be trained in advance and should vary in size and thickness. Ideally, the bonsai should be a mature tree with a shallow root system. It is not important, however, that the bonsai be fully grown, since defects in the bonsai are relatively easy to conceal.

Fig. 103. Lightweight stones for use in tray landscapes or rock plantings being aged in an outdoor water basin. Place of origin: United States (New York).

Many tray-landscape artists prefer to use evergreen trees, especially pine, juniper, azalea, dwarf box, and spruce because their appearance remains fairly constant all year round. Other highly recommended outdoor species are cryptomeria, bald cypress, larch, cotoneaster, oak, elm, hornbeam, beech, zelkova, spirea, Japanese yew, various flowering quince, fir, cedar, and cypress. Dwarf lilac and miniature rose have also been used with great success. Recommended indoor species are Fukien (Fujian) tea, dwarf gardenia, serissa, orange jasmine, fig, dwarf star-jasmine, malpighia, dwarf myrtle, olive, pomegranate, and Norfolk Island pine.

The mixing of different species in a single tray landscape can at times produce an overly busy appearance. Many tray-landscape artists therefore prefer to use only one species, but this is not a hard-and-fast rule. The important point to keep in mind is that trees of the same species should be grouped together rather than spread randomly throughout the landscape. Also, plants with radically different repotting time-intervals or soil and water requirements—such as indoor and outdoor trees or alpine trees and cactus—should not be planted in the same tray landscape. Similarly, trees with roots that grow at different rates should not be combined, since the roots of the faster growing plant will dominate the landscape.

Selecting other plant material

Ground-cover plants with strong roots and small leaves that grow close to the ground can effectively be used in tray landscapes to accent the suiseki or bonsai. To survive, they should be hardy and capable of thriving in the shade. Recommended outdoor varieties of ground cover are dwarf saxifraga, fern, bluet, dwarf violet, dwarf horsetail, and various succulents. For tray landscapes that are to be kept indoors, dwarf bamboo, dwarf sweet-rush, and baby's tears are highly recommended.

Mosses and lichens can also enhance the beauty of virtually any tray landscape. Mosses do not, however, grow well indoors. Besides ordinary green moss, several varieties are recommended for their luxuriant softness and water-retention properties, including pink earth lichen, red lichen, silver lichen, spongy green moss, and long green moss (Cryptomeria moss). It is best to avoid liverwort, since this type of plant grows vigorously and will form a thick mat that will not allow moisture through to the soil. Moss can easily be collected, since it grows nearly everywhere. The best time to gather moss is immediately after a rainstorm. It should be lifted with a knife or spatula and temporarily stored between layers of dry newspaper. After unwrapping, the moss should be spread out immediately in one layer and exposed to the air.

Design

Tray landscapes are generally more difficult to create than rock plantings and individual bonsai. The artist must be able to work with the individual subjects and be able to balance and interrelate a large array of shapes, textures, colors, and spaces. As a guide, the principles of tray-landscape design described below can be helpful. These principles are not, however, absolute rules: some of the most striking tray-landscape designs seem deliberately to violate them.

1. EMPHASIS: Emphasis means focusing more attention on the most important elements and less attention on elements of lesser consequence. Many first attempts at tray-landscape design suffer from a lack of appropriate emphasis and precedence. Either everything has the same degree of unimportance or, at the opposite extreme, the landscape has too many significant elements simultaneously competing for attention. By comparison, a well-designed landscape focuses the attention of the viewer on only one feature of the landscape; this can be a single object or a closely integrated group of objects. Tray landscapes of this kind

result neither in boredom nor overstimulation. The viewer's attention is held and then relaxed.

The first step in designing the tray landscape is to evaluate the visual impact of each element on the viewer. A large-sized suiseki or bonsai commands respect. Objects that are brightly colored, such as flowering bonsai, or that are characterized by strong contrasts also have strong visual impact. A highly detailed suiseki or bonsai arouses interest, while anything unusual or unexpected assumes greater importance. In theory and practice, the visual impact of a medium-sized bonsai with bright flowers is greater than that of a large gray suiseki.

In creating a pattern of emphasis, the terms "focal point," "subdominant element," and "subordinate element" are often used. The focal point of the tray landscape, or major point of interest, should be the landscape feature with the strongest visual impact. A tray landscape should have only one focal point. If two landscape features are approximately equal in their visual impact, one should be eliminated. Landscape elements with less visual impact should be used as subdominant elements, and landscape elements with the least visual impact should be used as subordinate elements.

In line with this terminology, the tray landscape shown in Figure 114 might be analyzed in the following way: the focal point is the tall Waterfall stone covered with small plantings; the subdominant elements are the Coastal rock stone and the bonsai planted in the central section; and the subordinate elements are the stream, ground cover, and smaller stones and plants. A more detailed analysis will clarify how these different levels of emphasis are created. Because the Waterfall stone is massive and sits high, overlooking the landscape, it is the focal point of the composition, immediately drawing the eye of the viewer. At the next level, the bonsai and the Coastal rock stone in the center section, sitting squarely in the middle of the landscape, stand out and assume significance. In turn, the stream, grass, small stones, and vegetation, as part of the background, take on their accustomed roles as subordinate elements.

Other materials and designs could lead to different patterns of emphasis. If needed, the focal point can be given greater emphasis through the use of accent plants and ground cover. The plants should be tightly grouped and planted in such a way that they accentuate the major point of interest.

For maximum effect, the focal point in a tray landscape is nearly always placed off-center. It generally lies about one-third the distance from the edge of the tray and slightly behind an imaginary horizontal line running through the middle of the tray. Occasionally it will lie near the left or right edge of the tray.

2. BALANCE: In Chapter 2 it was noted that the balance of a suiseki is created by the dynamic interplay and equilibrium of several opposite yet complementary characteristics of the stone. The balance of a tray landscape is similarly determined by the interplay and balance of opposite yet complementary aspects of the scene: high and low, large and small, soft and hard, dry and wet, light and dark, open and closed, hidden and explicit, simple and detailed, interrupted and continuous, smooth and rough, thick and thin, sparse and dense, empty and full, vertical and horizontal, convex and concave, straight and curved, delicate and massive, dynamic and quiet. The effect of a tray landscape that is designed in this manner is markedly different from a symmetrical landscape, where each feature of the scene is echoed by an identical feature. The balance of opposing yet complementary features calls to mind the variety, rhythms, irregularity, asymmetry, and wildness of nature; it also suggests vigor, movement, spontaneity, and informality. Less obvious than symmetrical balance, it challenges the viewer to discover how the equilibrium is achieved.

Creating balance is made all the more challenging by the growth of plants and by changing light conditions. As trunks and branches become thicker and larger, or as the bonsai lose their leaves in winter, the balance will change and the landscape will be thrown out of proportion. The light that shines on a tray landscape is also changing, not only with the time of the day but also with the changing seasons and weather conditions. Only within small limits can outdoor light be controlled, yet it can affect a tray landscape drastically. To illustrate, a suiseki with subtle colors can be readily appreciated in moderately bright light, but the colors are almost obscured in poor lighting conditions. In view of these inevitable changes, many of them beyond the artist's control, there are two alternatives: the artist can design the landscape so that it is strong enough not to be diminished by these changes, or can adapt the landscape to changing conditions, redesigning or repositioning landscape elements as necessary.

One of the principal devices used in creating balance, and in design-

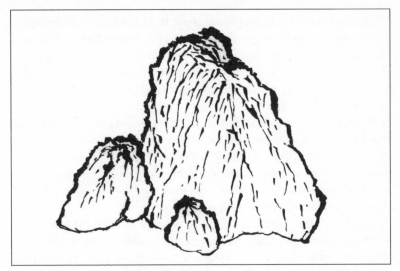

Fig. 104. An asymmetrical triangular arrangement of three stones copied from the original seventeenth-century edition of *Chieh-tzu Yüan Hua-chuan* (The Mustard-Seed Garden), a Chinese painters' manual.

ing the landscape as a whole, is the asymmetrical triangle. In virtually all tray landscapes having more than two elements, every significant element occupies at least one corner of an asymmetrical triangle. Figure 104 shows a typical asymmetrical composition of three stones. This particular composition, traditionally known as a *sanzon*, or Buddhist triad arrangement, has the tallest stone placed centrally with two smaller stones of unequal size set on either side for balance. Two even smaller stones are occasionally placed at the front and back of the triangle to provide additional balance and depth.

Groups of elements can also be arranged to form an asymmetrical triangle. In some tray landscapes, a grove of trees—itself asymmetrically arranged—functions as one corner of an asymmetrical triangle, with other sections of the landscape serving as the other two corners (see Fig. 114). In more complex designs, one corner of the asymmetrical triangle is sometimes left empty, to be filled in by the imagination of the viewer. A tray-landscape artist may also use one element in a triangular grouping as an element in another triangular grouping, resulting in a pattern of interlocking asymmetrical triangles. These triangles produce a landscape that is harmonious and balanced from every angle.

The shapes of the asymmetrical triangles are also an important factor in determining the formality of the overall design. Triangular forms that are nearly, though not actually, equilateral or isosceles generally give the landscape a more formal feeling. By comparison, triangular forms that are more obtuse or scalene generally give the landscape a more informal feeling.

In laying out a balanced design the various landscape elements should not form straight lines consisting of three elements arranged in a row, in a column, or along a diagonal. Also, various landscape elements should not form straight lines that parallel the edge of the container, nor should they form symmetrical geometric shapes, such as circles, squares, and equilateral triangles.

Tray landscapes containing a large amount of material can sometimes create special balancing and design problems. To simplify the task, some artists divide the tray into nine equal areas. In the occupied spaces, the various elements are arranged in groups of two, three, or five. Larger groups are broken down into clusters of two and three elements. If there is not enough material to fill out a suiseki or bonsai group, the problem is often solved through the strategic placement of ground cover, vegetation, and small stones.

3. RHYTHM, VARIETY, AND CONTRAST: These qualities are closely related to balance. They are achieved by systematically increasing or decreasing various features or aspects of the landscape, such as the textures, heights, and spacing of the bonsai and suiseki.

Rhythm, variety, and contrast contribute to the beauty of a tray landscape in several ways. First, the landscape gains both interest and harmony. Second, the tray landscape becomes dynamic and animated by the implied movement and direction that rhythm, variety, and contrast produce. Finally, the unique chararacter of the landscape is at least partially determined by the way the various rhythms are contrasted, linked, and organized.

In the finest tray landscapes there is a subtle mutual dependence and interrelationship between the various aspects, not just contrast and variety. Each suiseki and bonsai responds to the invisible lines and curves projected across intervening spaces by other elements in the landscape, and each element receives added life through these linkages and interrelationships. Using Figure 114 to illustrate the point, the Waterfall stone set on the left side and the Coastal rock stone set in the center of

the tray are connected by an imaginary line extending from the tip of the cascading bonsai, planted on the top of the Waterfall stone, to the tips of the bonsai planted on top of the Coastal rock stone.

In traditional Japanese designs, the rhythms of the landscape typically flow from left to right. A tray-landscape artist might design a river, for example, to flow in a left-to-right direction, with its source (possibly a Waterfall stone) set on the left side of the tray (see Fig. 113).

Rhythm, variety, and contrast in a tray landscape are exemplified by the sequence of curves made by a winding road or river, or by a progression of low points and high points as the eye moves across or through a landscape. To keep from hindering this movement, some empty space is often left at the front and at the ends of the tray. Unless the object is the focal point of the tray landscape, subjects that are tall or sharply vertical are generally not positioned near the edge of the tray, as this may force the viewer's eye movement to come to an abrupt halt. Consistent with the principles already described, suiseki and bonsai of the same height or width are generally not positioned next to one another, nor should equal amounts of space be left between the various elements.

4. PERSPECTIVE : A tray landscape should convey to the viewer an illusion of depth. To achieve this, it is important that the rules of perspective be observed in designing all features of the landscape. Since objects become smaller, less detailed, and softer in color as they recede into the distance, the largest, the most highly detailed, and the darkest suiseki and bonsai are often placed nearer to the viewer; smaller, less detailed, and softer colored materials are placed in the background. The illusion that parallel lines, such as those formed by trees bordering a long straight road, come closer together as they recede into the distance can also be exploited in creating perspective.

The design of a river in a tray landscape can be used to illustrate how these rules of perspective are applied in practice. First, perspective is added by placing the widest point of the river in the foreground and the narrowest point in the distance (see Figs. 114, 116). To enhance the effect, the darkest and largest sand particles, tones, and plants should be placed in the foreground, with the lightest and smallest placed in the background. Second, since a river that runs in a straight line lacks depth, it should be made to widen as it slowly meanders through the landscape following a rhythmic and sinuous pattern. Third, the illusion of depth and perspective, as well as a sense of mystery, is heightened by

only suggesting or by concealing the source of the river. The river can, for example, be made to issue from behind and between two cliffs, or from behind an overhanging tree or bush. Depth and mystery can be further enhanced by having the river or road temporarily disappear, perhaps into a forest or behind a mountain (see Fig. 113).

The four major principles of tray-landscape design just described are not always applied self-consciously: more often they are noted only when they are violated. Once the principles are understood and mastered, it will be easier for the beginner to comprehend what needs to be improved or corrected. By studying landscape designs that have worked in the past, the beginner can gradually develop a more refined sense of design.

Methods

All materials for the tray landscape should be assembled in advance: suiseki, ordinary stones, bonsai, grasses, moss, other plant material, peat muck, soil, mesh screening, wire, tools, and the tray (Figs. 117-122). Additional plants and stones should be kept on hand, since additions and substitutions are often needed. Before being planted, the bonsai should be trimmed, wired, and pruned into its basic shape; however, final trimming, wiring, and pruning should be done only after all materials in the arrangement are in place.

It is important for the tray to have drainage holes in the bottom that are at least ½ inch in diameter. After covering these holes with thin plastic or non-corrosive screening, the tray is filled one-half to three-quarters full with coarse bottom soil. Working from the focal point, the suiseki and other stones are arranged by imbedding them firmly on a pad of peat muck. The advantage of using peat is that the height and slant of the stones can be varied. The peat also acts as a base for an unstable stone. If the stone refuses to stay in place or seems wobbly, it can be further stabilized by bracing it against several smaller stones glued to its base with waterproof quick-drying cement.

Bonsai are usually planted in the soil or on a pad of peat muck after the suiseki are in place, unless the bonsai will be the focal point of the arrangement. If the bonsai are planted in a group, branches from interior trees should not extend beyond the trunks of trees forming the outer edge of the group. The height and slant of the bonsai can be adjusted by varying the height of the peat or soil. If a bonsai will not

stay in position, it can be secured with copper wires drawn through the drainage holes.

Before proceeding to the next step, the landscape should be reviewed for any bonsai or suiseki that are superfluous. Simplicity is the key to a successful design: a tray landscape is completed only after nothing more can be removed without upsetting the balance. After all bonsai and suiseki are in place, potting soil can be added. The soil should be worked into the roots with chopsticks, making sure that all air pockets are eliminated. Soil and peat muck should also be worked under the suiseki, making sure the undersides of all suiseki are covered; otherwise, the stones will appear unstable.

After brushing off excess soil, a small amount of peat muck can be molded and contoured to form hills and valleys. Care should be taken, however, not to use too much, as excessive amounts may disturb drainage. In shaping the peat, at least some parts of the landscape should be kept level. Such level areas allow the eye to rest, suggesting a place where a weary traveler might comfortably sit down or camp.

Vegetation and moss can then be added. Tray landscapes that are to be kept outdoors should be covered with moss of varying texture and color. The moss should not, however, completely blanket the surface, as this will deprive the roots of air. To promote drainage, the amount of soil originally adhering to the underside of the moss should be less than $1/16$ inch thick. Excess soil can be scraped away with chopsticks or pointed tweezers before the moss is laid.

Ground cover, including baby's tears, can be used as a substitute for moss if the tray landscape is to be kept indoors. As baby's tears grow rapidly, regular trimming of top growth will be necessary to keep the plant under control.

After the arrangement is finished, it should be thoroughly watered, both from above, using a watering can or sprayer, and from below, by setting it in a container filled with water. If sand is used, it should be added subsequent to the watering. It should be off-white, gray, or beige in color, since bright white sand is often too striking and will detract from the rest of the composition. The sand should also be relatively coarse, or it will scatter or wash away after several waterings.

As with any potted bonsai, the soil will need to be changed periodically. The tray landscape should be transplanted carefully, since the roots may have grown together or may have become attached to stones.

It is usually best not to separate these roots from one another or from the stones. If the attached roots, trees, and stones occupy less than about one square foot, they should be transplanted as a single unit.

KETO-BONKEI, BONSEKI, AND HAKO-NIWA

Apart from bonsai, suiseki is closely related to three other art forms that use miniature landscape stones: *keto-bonkei, bonseki,* and *hako-niwa.*

Keto-bonkei

Keto-bonkei (lit.: *keto,* peat-clay, *bonkei,* tray landscape) was established as a new school of Japanese tray-landscape design in 1887. The characteristic that distinguishes keto-bonkei from traditional bonkei is the extensive use of *keto,* a dark brown peatclay formed from decayed vegetable matter and silt. The keto, together with suiseki, ordinary stones, small pebbles, natural or artificial plant materials, moss, soil, gravel, and sand, is used to form major elements in the landscape, including mountains, hills, rocks, and fields (Fig. 137). The keto is typically coated with colored liquid-clay and can be expected to last for about one month before disintegrating. The landscape is then reconstructed or the materials are recycled.

Keto-bonkei tools include metal spatulas for modeling the keto, brushes for smoothing surfaces and for cleaning away debris, small sieves and spoons for applying sand, syringes for removing excess water, a sprayer for watering the completed landscape, pincers, and a specially designed wooden worktable. The shape of the tray is typically oblong or oval, and its size should fall within the following range of dimensions: 12 to 26 inches long, usually 16 to 18 inches; 6 to 18 inches wide, usually 10 to 12 inches; and ¾ to 3 inches deep, usually ¾ to 1 inch. Keto-bonkei trays have no drainage holes and are made of metal, porcelain, pottery, concrete, or, more rarely, well-seasoned wood with a waterproof lining (metal or lacquer). Rivers, streams, waterfalls, lakes, seas, and waves are represented in the tray by various grades of sand, to which blue pigment is sometimes added. Real plants—sometimes with their roots removed—and artifical plants are also used to create scenery, as are miniature farmhouses, pagodas, shrines, bridges, and figurines representing humans and animals. The most common keto-bonkei

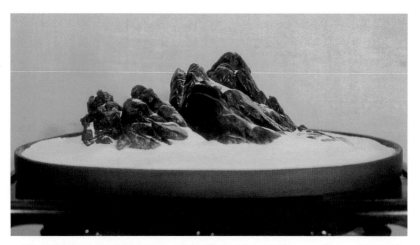

Fig. 105. Mountain stone set in a suiban filled with sand. The use of pure-white sand is a radical departure from traditional practice. The sand is intended to represent drifting snow and enhances the power of the stone to suggest a natural scene such as that depicted in Figure 106.

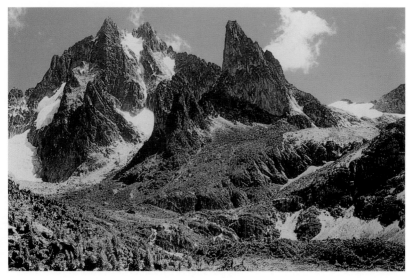

Fig. 106. View of a snow-covered alpine mountain.

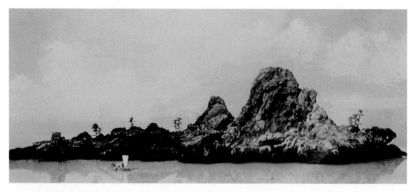

Fig. 107. Island stone with a miniature sailboat, an unobtrusive accessory which enhances the suggestion of an island.

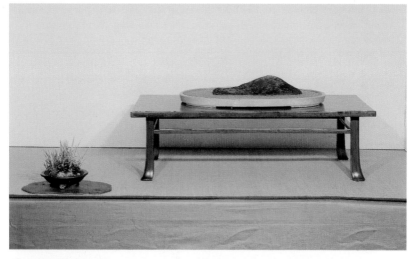

Fig. 108. Distant mountain stone informally displayed with a planter containing grasses. Each element in this harmonious asymmetrical arrangement reinforces the seasonal theme of the display: a peaceful summer day in the country.

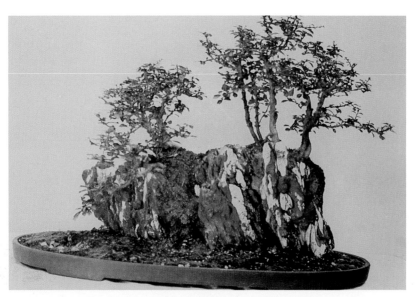

Fig. 109. Multiple-trunk style. Bonsai species: Fukien (Fujian) tea.

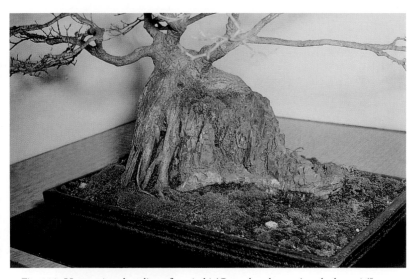

Fig. 110. Harmonious bonding of a suiseki (Coastal rock stone) and a bonsai (Japanese common maple). To show stability, some of the roots have been trained down the front side of the stone.

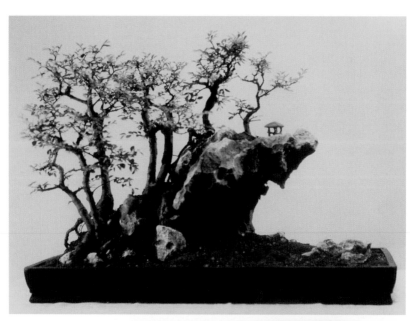

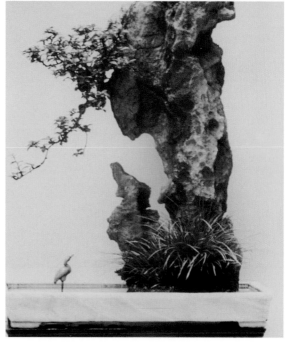

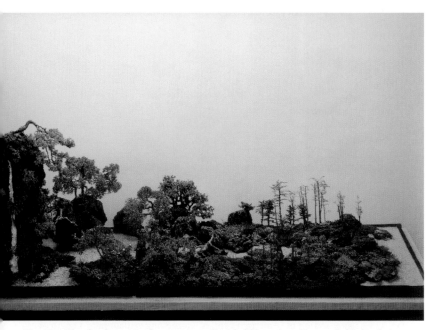

Fig. 113. Tray landscape in three sections. Entitled "American Fantasy," this bonkei was created by Yuji Yoshimura in 1981. It depicts a river running from its source at the waterfall through various types of terrain. Length of display. 6½ feet (2 m.). Width: 2 feet (0.6 m.). Depth of wooden container: 2 inches (5 cm.). For additional detail, see Figures 114-116.

(Facing page, from top)
Fig. 111. Rock planting in the root-over-rock style: Japanese elm on Shelter stone. The miniature house enhances the overall suggestiveness.

Fig. 112. Rock planting in the clinging-to-a-rock style: Fukien (Fujian) tea and grasses on Near-view mountain stone. The miniature bird accessory enhances the suggestiveness of the display.

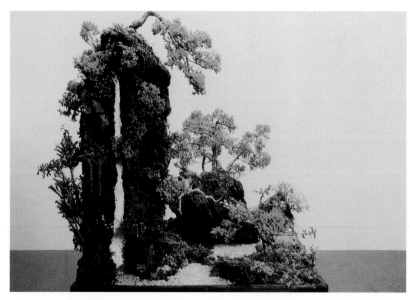

Fig. 114. Left-hand section of the tray landscape "American Fantasy," suggesting rugged mountains. From both an aerial and frontal view, the groups are arranged to form an asymmetrical triangle. For enhanced perspective, the stream narrows and disappears briefly as it meanders from the front of the tray to the back. Length of display: 2½ feet (0.8 m.). Width: 2 feet (0.6 m.).

Fig. 115. Center section of "American Fantasy," suggesting verdant hills. Length of display: 2½ feet (0.8 m.). Width: 2 feet (0.6 m.).

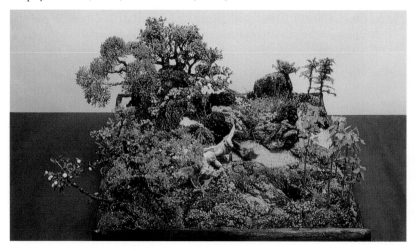

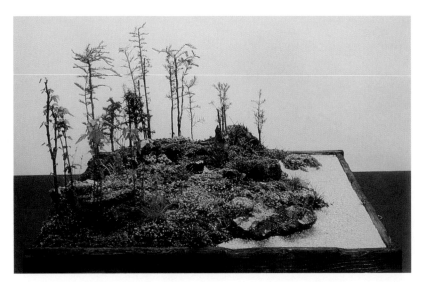

Fig. 116. Right-hand section of "American Fantasy." For added depth, the "water" is wider in the foreground and narrower in the distance. Length of display: 1½ feet (0.5 m.). Width: 2 feet (0.6 m.).

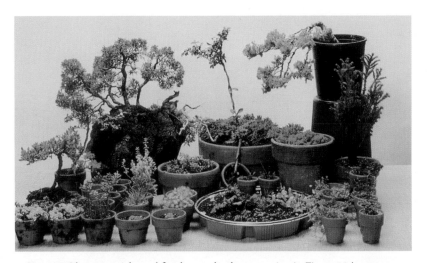

Fig. 117. Plant materials used for the tray-landscape section in Figure 114: procumbens juniper, dwarf Sawara cypress, Kingsville box, dwarf azalea, dwarf cranberry, Sargent juniper, serissa, bean fern, golden fern, mosses, and lichens.

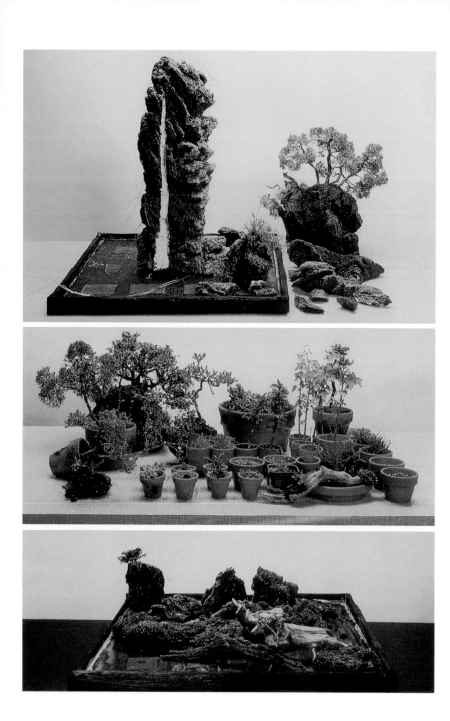

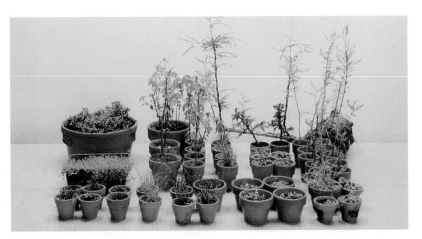

Fig. 121. Plant materials used for the tray-landscape section shown in Figure 116: trident maple, bald cypress, and grasses.

Fig. 122. Stones used for the tray-landscape section shown in Figure 116.

(Facing page, from top)

Fig. 118. Stones used for the tray-landscape section shown in Figure 114.

Fig. 119. Plant materials used in the tray-landscape section shown in Figure 115: Sargent juniper, serissa, dwarf pieris, dwarf needle-juniper, procumbens juniper, dwarf cryptomeria, trident maple, sedum, dwarf saxifraga, dwarf veronica, dwarf violet, dwarf mint, golden fern, dwarf horsetail, mosses, lichens, and grasses.

Fig. 120. Stones used for the tray-landscape section shown in Figure 115.

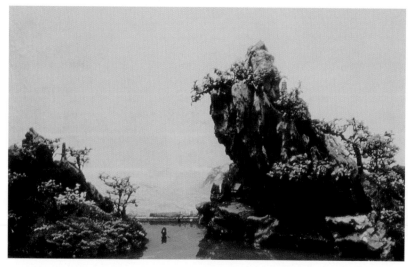

Fig. 123. A tray landscape created in China suggesting a rocky coast.

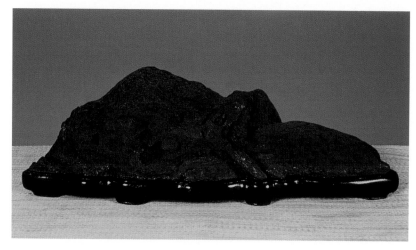

Fig. 124. Distant mountain stone, one of six suiseki in the collection of the U.S. National Arboretum. Height: approx. 5½ inches (14 cm.). Place of origin: Japan (Ibigawa, Gifu). (The well-carved dai would be more refined if the legs were spaced more irregularly.)

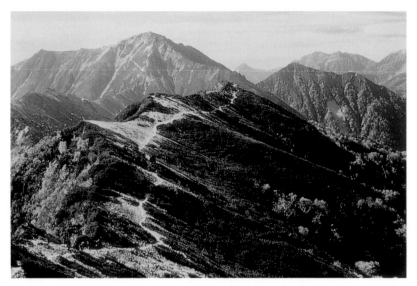

Fig. 125. View of the Japan Alps. Refer to Figure 142.

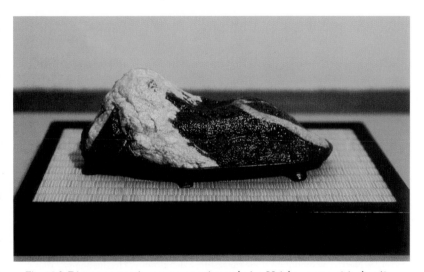

Fig. 126. Distant mountain stone suggesting a glacier. Height: approx. 3 inches (8 cm.). Place of origin: United States (California).

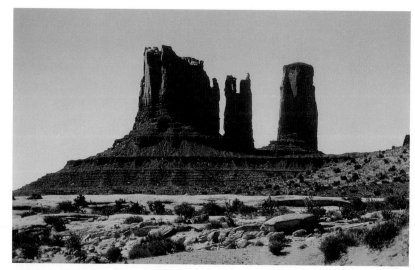

Fig. 127. View of a desert formation in the American Southwest.

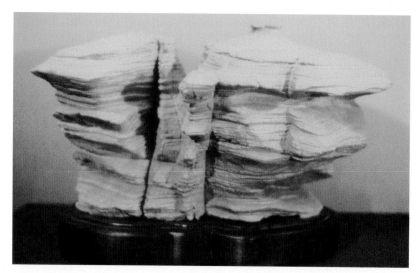

Fig. 128. Near-view mountain stone suggesting a desert butte. Height: approx. 10 inches (25 cm.). Place of origin: United States (California).

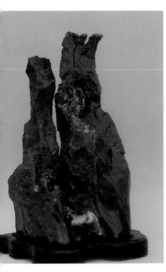

Fig. 129. Near-view mountain stone suggesting two desert pinnacles. Compare with Figure 127. Height: approx. 7 inches (18 cm.). Place of origin: United States (California).

Fig. 130. Mountain stone suggesting a tall, sharp-pointed peak. Place of origin: Taiwan.

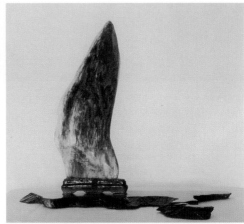

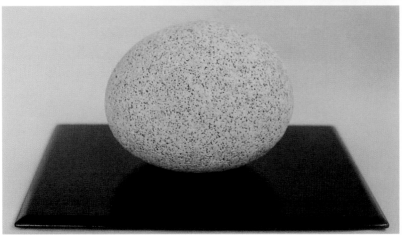

Fig. 131. Object stone suggesting an ostrich egg or cantaloupe. Height: approx. 5 inches (13 cm.). Place of origin: United States (Maine).

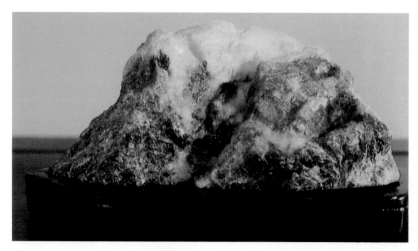

Fig. 132. Distant mountain stone suggesting a single-peaked, snow-capped mountain. Place of origin: United States (Georgia).

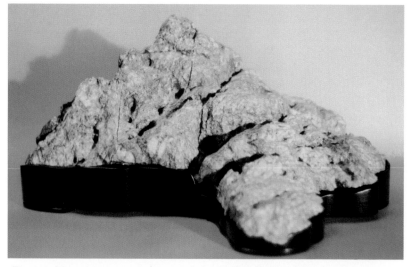

Fig. 133. Near-view mountain stone with deep indentations suggesting ravines and gorges. Height: approx. 5 inches (13 cm.). Place of origin: United States (California).

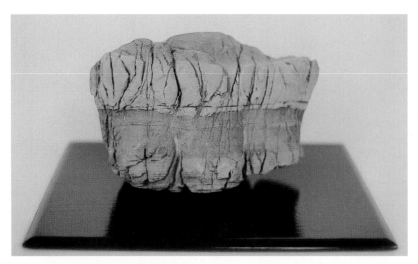

Fig. 134. Thread-waterfall stone. Height: approx. 6 inches (15 cm.). Place of origin: United States (Washington).

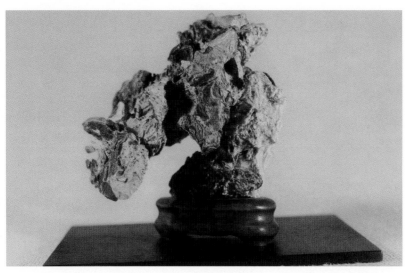

Fig. 135. Object stone suggesting an animal or bird. Place of origin: United States (California).

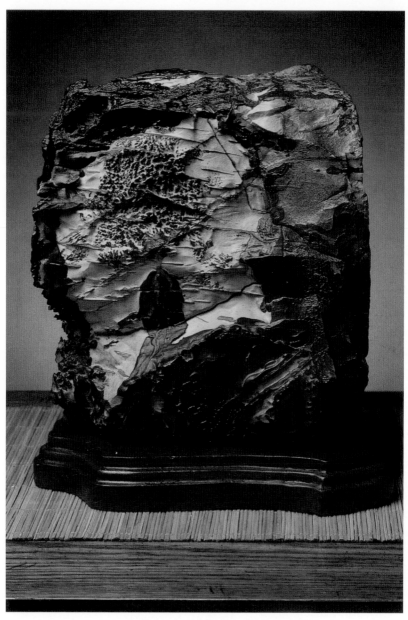

Fig. 136. Pattern stone suggesting a tree perched on a rocky promontory.
Height: approx. 6 inches (15 cm.). Place of origin: United States (California).

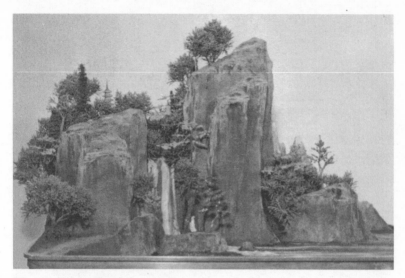

Fig. 137. An example of a keto-bonkei.

motifs are mountain or seaside locations noted for their scenic beauty. For subject matter, many keto-bonkei artists use traditional copybooks that contain prints or drawings of landscapes and seascapes.

Bonseki

Bonseki (lit.: *bon,* tray, *seki,* stone or stones) is one of the original terms for suiseki. In modern usage the term refers specifically to a landscape scene created by sifting and arranging white sand onto a black-lacquered tray using spoons, small sieves, tiny brooms, thin rectangular boards, cutting dies, chopsticks, and feathers (Figs. 138-141). The major features of the landscape, including mountains, hills, and islands, are represented by sand arranged in intricate patterns or by a black or dark gray suiseki. In some bonseki schools, green, white, tan, and red sand, pebbles, and suiseki are used to indicate the various seasons. The suiseki are generally 6 to 9 inches wide at the base, 4 to 7 inches high, and sawed flat at the bottom for stability.

Rivers, oceans, lakes, waves, clouds, and waterfalls are also represented by sand. Bonseki artists of the Hosokawa school, one of the oldest bonseki schools in Japan, classify the pure-white sand into nine types according to the size of the grain (see Fig. 141).

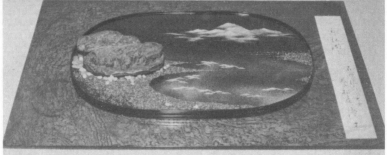

Fig 138, 139. Examples of bonseki.

Other elements in the landscape, including small rocks, villages, and forests, are often represented by a mass of sand or pebbles. In contrast to keto-bonkei, neither soil nor plants are used.

In the Hosokawa school, trays are made of lacquered wood and have a low rim, ½ inch to 2 inches high, or no rim at all. The tray or board is ½ to 36 inches long, usually about 18 inches; 6 to 12 inches wide, usually about 9 inches; and is typically rectangular or oval in shape. Sometimes the tray will be in the shape of a fan or a leaf. As in keto-bonkei, tiny bridges, boats, pagodas, temple gates, houses, and figurines (animal and human), often made of bronze, copper, or ivory, are occasionally added to the arrangement.

Bonseki motifs are quite varied, including landscapes and seascapes, seasonal representations, and noted places of scenic charm or historic interest. The color scheme is kept quite simple and elegant—usually only black (the tray and stones) and white (the sand). Virtually all of the materials can be recycled over and over again. Used sand is sifted, classified, and stored away, together with tools and other materials, in a small chest of drawers (see Fig. 141).

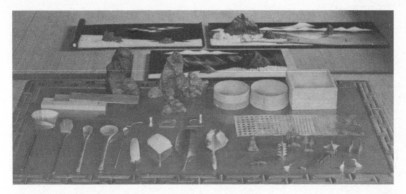

Fig. 140. Tools and materials used in creating a bonseki.

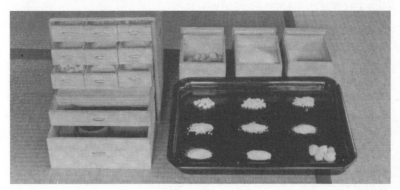

Fig. 141. A chest of drawers containing bonseki materials, and a tray showing different types of sand classified according to the size of grain.

Hako-niwa

Much older than either keto-bonkei or bonseki is *hako-niwa* (lit.: *hako*, container or box; *niwa*, garden). Hako-niwa is the art of creating a miniature garden in virtually any kind of container using a variety of natural and artificial materials. Modern hako-niwa tend to be highly realistic. A large one may occupy an entire small backyard, and will often replicate in miniature an actual Japanese garden, including hills (represented by suiseki), miniature ponds (stocked with small fish), stone lanterns, water basins, wooden bridges, and real or artificial plants.

CHAPTER 6

Collecting Suiseki

COLLECTIONS AND EXHIBITIONS

In Japan, public exhibitions of suiseki are held in nearly every large city and in many smaller towns. In addition to the national and international suiseki exhibitions sponsored by the Japanese Suiseki Association and the Japanese Bonsai Association, local suiseki and bonsai clubs throughout the country organize periodic exhibitions. The time and location of these exhibitions may change from year to year, and updated information can be obtained by consulting Japanese bonsai and suiseki publications or by asking commercial suiseki dealers.

Several Japanese museums and temples also have suiseki in their collections, and these stones can be seen by appointment or on the occasions they are exhibited. The Nezu Museum in Tokyo, the Tokugawa Art Museum in Nagoya, and the Nishi Honganji temple in Kyoto, for example, periodically exhibit suiseki from their collections.

Although there are many private collections of suiseki in Japan, these are generally not open to the public. Private appointments can, however, often be arranged through a dealer or through personal contacts. Visits to private collections are also sometimes included in specialized tours of Japan organized by bonsai clubs in various countries.

Suiseki are publicly exhibited in countries other than Japan, but on a more limited basis. In 1973, for instance, a major exhibition of suiseki and meiseki was held at the Los Angeles County Natural History Museum. The exhibition, sponsored by the Los Angeles-Nagoya Sister-City Affiliation and the Chubu Region Rock Collectors Association, included over 120 stones. Suiseki can also be viewed at national and local bonsai conventions held annually in numerous countries. Many

local bonsai clubs also hold special workshops devoted to the appreciation of suiseki and their use with bonsai.

As mentioned earlier, one of the finest permanent collections of suiseki outside Japan is housed at the U.S. National Arboretum in Washington, D.C. The Arboretum has six excellent suiseki in its collection. These stones, together with fifty-three rare bonsai, were presented to the American people by the Japanese Bonsai Association in commemoration of the 1976 American Bicentennial (Fig. 124; see Figs. 34, 38, 44, 49, 58). The gift was supported in part by a grant from the Japan Foundation. In the United States, suiseki are also exhibited in the Bonsai Court of the Huntington Botanical Gardens located in San Marino, California.

THE ART OF COLLECTING

The goal of most suiseki collectors is to amass a collection containing at least one high-quality example from each major suiseki classification, subclassification, category, and subcategory. Some collectors also specialize in particular types of stones, including suiseki representing (1) a particular category, (2) a particular locality, (3) a particular color or surface texture, (4) a particular mineral or rock type (for example, basalt or limestone), and (5) a particular size, such as miniature suiseki. Some collectors also specialize in suiban and make a concerted effort to obtain at least one example from each major kiln.

Japanese suiseki collections are often quite different from non-Japanese suiseki collections. Over the centuries, the Japanese have developed a preference for particular types of stones, based in large part on a unique set of geographical, geological, and cultural factors (Figs. 125, 142). Probably the most important factor is that Japan is a small and mountainous Pacific island-nation with a long, rocky coastline. Four-fifths of the country is covered by mountains separated by deep valleys and rushing streams. It should come as no surprise, therefore, that suiseki resembling mountains, islands, waterfalls, and mountain streams are especially popular among Japanese suiseki collectors. As mentioned in Chapter 1, the Japanese preference for particular types of stones is also based, in part, on a rich synthesis of several religious and philosophical traditions, including Buddhism, Shintoism, and Chinese philosophy.

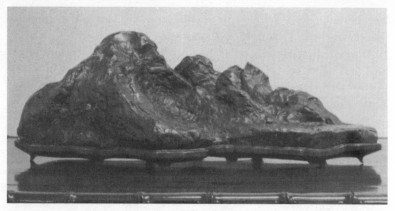

Fig. 142. Distant mountain stone suggesting a view of the Japan Alps, such as that shown in Figure 125. Stones of this type are especially prized by Japanese collectors. Place of origin: Japan.

In other countries, preferences for particular types of stones are also based on geographical, geological, and cultural factors that are unique to the country. In the United States, for example, large collections of desert stones have been amassed by suiseki enthusiasts in California. These stones suggest desert formations (buttes, mesas, sand dunes, and arched rock outcroppings) that are unique to that part of the United States (Figs. 127-129). The colors of these suiseki are the warm tones of the desert sun and sand—colors that are quite different from those favored by Japanese collectors.

In the finest collections, new additions are carefully cataloged. Each stone is assigned a catalog number and a record is made containing this, together with the geographical place of origin, the classification, the poetic name, and the dimensions. A more complete record might also contain the date acquired, the dealer and cost (if the stone was purchased), the names of previous owners, the mineral content and type of rock, and any other interesting or descriptive information. Usually, the catalog number also appears both on the bottom of the stone and on the bottom of the dai, affixed by means of a stick-on label. In the past, pertinent information about the stone was often written on a scroll or on the lid of a box made especially for the stone (Fig. 143). A suiseki that has had several owners might be accompanied by several scrolls or boxes. In modern times, scrolls and box lids are seldom used to keep

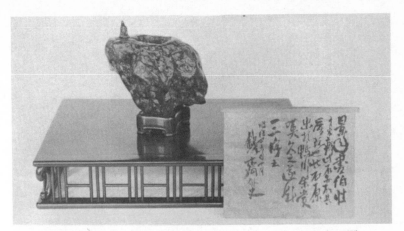

Fig. 143. Waterpool stone displayed with the lid for the stone's storage box. The stone's place of origin and other information are written on the lid. The miniature accessory at the edge of the pool represents the goddess Kannon. Place of origin: Japan (Kamogawa, Kyoto).

records; instead, most collectors use file or index cards. If the suiseki is later sold or traded, the old record is frequently preserved, even if a new record is made.

COMMERCIAL MARKETS

Suiseki and suiban can be purchased and viewed in special showrooms or in the bonsai sections of the larger Tokyo department stores. Suiseki can also be purchased and viewed in other stores throughout Japan which specialize in suiseki, bonseki, bonsai, bonkei, or gemstones. Many of these stores, especially the larger ones located in Tokyo, Kyoto, Osaka, and Nagoya, regularly advertise in Japanese bonsai and suiseki magazines. Considering the close relationship between suiseki and bonsai, it should come as no surprise that many Japanese bonsai nurseries also sell suiseki and suiban. Suiseki are also sold at monthly auctions held in several Japanese cities. Most of these stones are later sold to private collectors or to specialty stores.

Opportunities to buy suiseki outside Japan are much fewer. Most non-Japanese collectors obtain their stones through trading or field collecting. Recently, however, commercial nurseries and bonsai-supply stores have begun to carry suiseki and suiban as part of their regular stock.

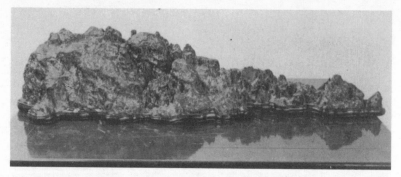

Fig. 144. Near-view mountain stone with an intricately carved dai.
Place of origin: Japan.

VALUATION

Several factors play a role in determining the value of a suiseki. Assuming that the suiseki is a good representative of its type (an Island stone or a Waterfall stone, for example) and has acceptable color, texture, and balance, it often loses value if it has been cut, chiseled, polished, painted, or altered in any way. The stone will also lose value if it has been chipped or bruised.

By comparison, a stone generally gains value if (1) it has natural white markings at its peak (suggesting snow or mist), at its base (suggesting crashing waves), or crossing the front side (suggesting a waterfall or mountain stream); (2) it is a combination of several types, such as a Distant mountain stone with features suggesting a waterfall, or a Waterpool stone with the pool surrounded by several mountain peaks; (3) it comes with one or more boxes or scrolls documenting its pedigree, especially if the stone belonged at one time to a famous public figure; (4) it comes with a well-carved dai (Fig. 144); (5) it represents a famous scenic spot, such as Mount Fuji; or (6) it represents a popular subject, such as a chrysanthemum flower. Chrysanthemum-pattern stones —especially sizable, unpolished stones with large flower designs, well-formed petals, and a distinct center—are greatly prized by Japanese collectors.

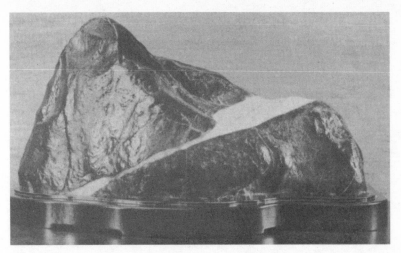

Fig. 145. Distant mountain stone suggesting a mountain glacier.
Height: approx. 6 inches (15 cm.). Place of origin: Canada (British Columbia).

GUIDE TO FIELD COLLECTING

Although most of the important sites in Japan are rapidly being depleted, outstanding specimens can still be collected wherever there are mountains, fields, valleys, shorelines, and river beds—in short, nearly everywhere.

Since a particular site can yield more than one good specimen, collectors frequently record the location of their finds. Japanese collectors are especially diligent in keeping such records. As was noted in Chapter 2, Japanese suiseki are often named, at least in part, after the place where they were originally found. The same chapter also described some of the most famous Japanese suiseki collection sites. These include Neo-dani in Gifu prefecture, Furuya in Wakayama prefecture, and the Saji-gawa, Setagawa, Kamo-gawa, and Ibigawa rivers.

High-quality suiseki have also been found in other areas of the world (Fig. 130). In North America, collectors have discovered excellent Waterpool, Thatched-hut, Waterfall, Island, and Object stones in New England and Nova Scotia; well-formed Mountain stones in the creeks of the Appalachians, Rockies, Sierras, and the northern Cascades; fine Object and Distant mountain stones in the California Mojave Desert;

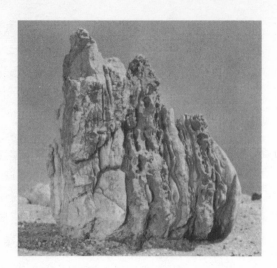

Fig 146. Dry waterfall stone. Height: approx. 14 inches (36 cm.). Place of origin: United States (New York).

and interesting Flower-pattern stones along the coast of British Columbia (Figs. 126, 131-136, 145, 146).

Suiseki collectors have traditionally favored sites known for their hard stones. The hardness of a stone is determined by its ability to resist scratching and abrasion. Among mineralogists, hardness is measured on a numerical scale known as the Mohs' scale, which ranges from 1 (indicating the softest minerals, such as talc) to 10 (indicating the hardest minerals, such as diamonds). Each mineral classified by the scale can scratch any mineral that numerically precedes it, and can be scratched in turn by any mineral that follows it on the scale.

Mohs' Scale

Mohs	Description	Characteristic
1-2	Very soft	Can be scratched by a fingernail
2-3	Soft	Can be scratched by a copper coin
3.5-4.5	Semi-hard	Can be scratched by a penknife
5-6.5	Hard	Can be scratched by a file
7-10	Very hard	Cannot be scratched by a steel point

The most highly prized suiseki fall between hard and very hard, that is, between 5 and 7 on the Mohs' scale.

Because of their hardness, igneous and metamorphic rocks are the most suitable for suiseki. Among igneous rocks, the most preferred are diabase (gabbro), diorite, granite (especially biotite granite), rhyolite, andesite, and basalt (especially basalt with quartz or calcite veining or markings). Among metamorphic rocks, the most preferred are schist (especially chlorite, epidote, biotite, and piedmontite schist), gneiss (especially granite gneiss), and hornfels. Also in collections are rocks made of jade, agate, jasper, obsidian, serpentine, aventurine, limestone, sandstone, clay-slate, pyroxene, tuff, and shale. Most rock and mineral guides provide a complete description of each of these types of rocks. Detailed information on the location of major deposits can be obtained from mineral guide-books or from gemstone magazines, mineral societies, rock shops, museums of natural history, or university geology departments.

Well-formed suiseki are frequently found where the forces of erosion are most active. With some exceptions—such as areas lacking suitable geological material—the most promising sites are characterized by extremely high winds, continuously blowing sand, or powerful torrents of water. Experienced field collectors specifically report that high-quality suiseki are found in greater numbers in deep ravines and in the middle or upper middle sections of swift-flowing mountain creeks, both in the creek bed and on the banks and slopes above the creek. By comparison, stones collected in the upper sections of creeks, streams, and rivers are often too jagged or sharp to make a good suiseki, and stones collected in the lower sections are frequently too flat or rounded. Stones collected on sandy beaches also tend to be too flat or rounded.

After a promising site has been identified, the experienced collector surveys the area and maps out a route using topographical and geological maps. If permission is needed to enter an area or to collect minerals, it should be obtained well in advance. Many public forests and parks require special collecting permits that may take several weeks or months to acquire.

The basic tool kit of a suiseki collector includes a high-quality steel pick and hammer, a 10- to 12-inch cold chisel, a small shovel or trowel, and safety glasses to protect the eyes if stones must be chiseled or hammered (Fig. 147). All tools should be in good condition, with firm grips and sharp edges. Some optional, although useful, items are a hard hat for work in caves, mines, or quarries; pruning shears or a small saw

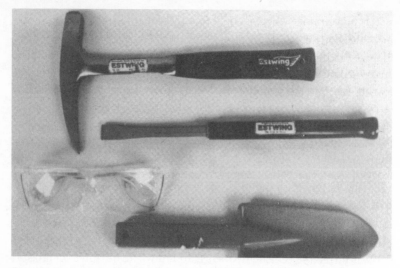

Fig. 147. Tools for the suiseki collector: a steel pick and hammer, a cold chisel, safety glasses, and a trowel.

for cutting roots away from stones; a long pry bar for loosening stones (the bar can also double as a walking stick); sturdy work gloves; and burlap, newspaper, plastic bags, or other material for wrapping and protecting specimens.

For long or overnight field trips, proper equipment and clothing are an absolute necessity. Clothing should be adequate for the climate, keeping in mind that mountain and desert weather can rapidly change. Clothing should also be able to withstand the rough wear it will receive. Loose-fitting pants made of denim, canvas, or cotton are the most practical for protecting the legs from insects, poison ivy, thorn bushes, and scrapes. In no case is it advisable to wear shorts. Clothing should be layered—an undershirt, shirt, sweater, and light jacket—so that successive layers can be removed as the day warms. A wide-brimmed hat will also provide protection from the sun's glare. On long trips, sturdy, high-quality boots are essential. They should be waterproofed and have nonslip soles for support and traction. Rubber boots are useful for wading through streams.

A backpack will be needed for carrying suiseki when vehicles are not available. Considering the weight of a typical suiseki— 5 to 25 pounds— it is essential that the backpack be sturdy and properly fitted. Most col-

lectors prefer packs with a strong frame and with a bag of heavy-duty nylon taffeta or heavy-duty nylon. Before purchasing a backpack, it should be tried on, fully loaded with 40 to 50 pounds of weight.

In addition to the items listed above, on long trips the field collector should always carry ten essentials: (1) a compass; (2) a flashlight with spare bulb and batteries; (3) extra food and water; (4) extra woolen clothing, especially a wool cap, and rainwear; (5) sun protection (including sunglasses and sunscreen lotion); (6) waterproof matches, fire-starter, and a short candle; (7) a first-aid kit; (8) a knife; (9) signaling devices, such as a whistle and a metal mirror; and (10) a waterproof emergency shelter.

It is best never to collect alone in remote areas. On long trips most suiseki collectors travel with other collectors, or join collecting expeditions organized by local mineral societies, bonsai groups, or hiking clubs. Collecting groups normally spread out according to interest, but voice contact should always be maintained with at least one person.

Before stones are actually collected, the area should be scouted. If a promising stone is found, the spot should be marked, possibly with a pile of stones or with a brightly colored tag. If the stone is eventually removed, the hole should be filled, thus preventing accidents.

Soil that adheres to the stone should be washed off in a stream or brushed off. The purpose of such cleaning is not to make the stone spotlessly clean and shining. The beauty of a suiseki is enhanced by a rich patina and other signs of age, and overcleaning can ruin a fine stone. For the same reason, care should be exercised in removing the stone from the ground and in wrapping the specimen at the collection site. It often takes years for a scratched suiseki to recover its original appearance.

Equipment in hand, and with the most careful planning, the first field expedition can nonetheless be a frustrating experience. Confronted by hundreds, or even thousands, of stones, it is difficult to know how or where to begin. In preparation for the expedition, the collector should study the various types of suiseki and train the eye by viewing as many examples as possible. Knowledge gained from these efforts will be an invaluable aid in quickly singling out the most promising stones.

How to Make a Carved Wooden Base

A custom-made base, or *dai,* can substantially enhance the beauty and value of a suiseki (Fig. 148). A suiseki does not have to be a museum piece to warrant a dai. If the shape, texture, and color of the stone are pleasing, the time involved in making a dai will be well worth the effort.

An absolute beginner, with only a minimum of tools and wood-working skills, can carve a simple yet satisfactory dai for a suiseki in a surprisingly short period of time.

Several factors need to be considered before work begins, including the type of wood, the tools to be used, the design of the dai, and an appropriate finish.

Wood

Many different types and grades of wood are available, and selecting the right one can prevent mishaps. All wood is classified by lumber specialists as either hardwood or softwood. Hardwood is the product of trees that lose their leaves in winter, such as walnut, oak, birch, and maple; softwood is the product of trees that have needles and cones, such as pine, spruce, fir, and hemlock. Unfortunately, this classification sometimes leads to confusion, since some types of hardwood are softer than some types of softwood. However, in the vast majority of cases the terms "hardwood" and "softwood" correctly describe the physical properties of the wood.

Some dai are made of softwood, such as red pine; however, carvers have traditionally preferred those made of hardwood, especially walnut, mahogany, teak, black sandlewood, and rosewood. Dai are also sometimes made of cherry, zelkova, maple, oak, and Chinese quince. Camphor wood is occasionally used, but rarely outside Japan. Al-

though hardwood is often more expensive and more difficult to carve than softwood, a dai made of hardwood is generally less likely to dent, warp, split, or break. Moreover, chisel cuts made in the wood tend to be cleaner, and hardwood often requires little or no surface treatment, the grain of the wood being sufficiently beautiful in its own right.

Since shrinkage and warping can create serious problems, most carvers buy the best grades of well-seasoned wood. If the wood is purchased from a commercial yard, it should be bought well in advance and allowed to season further. There is also an advantage in buying the widest board available, since the wood in wide boards tends to be higher in quality than the wood in narrow boards (wide boards are cut across the trunk, while smaller sections are sawed from various parts of the tree, including sapwood and branches).

As hardwood can be quite expensive, especially when bought by the board, costs can be reduced by buying or salvaging pieces of wood from a local cabinetmaker or furniture factory. Alternatively, pieces of wood can be salvaged from broken furniture. Occasionally wood suppliers accumulate short ends, and it may be possible to purchase these pieces at a reduced price.

Tools

In recent years power tools have become popular among dai carvers and can take much of the drudgery out of woodworking. Hand tools, however, are generally cheaper and give the carver a better feeling for the properties of the wood. Some carvers also feel that a dai made with hand tools is more personally satisfying. The tools should be of the best quality. It is difficult, and sometimes impossible, to carve a good dai with hand tools that are poorly constructed, out of balance, or difficult to keep sharp.

SAW: A basic item in a dai-carver's tool kit is a saw. Most straight cuts can be done with a fine-toothed backsaw, or tenon saw, approximately 12 inches long with 16 teeth per inch. For larger cutting jobs, a 24-inch handsaw with 10 teeth per inch is also useful. Curves are best cut with a compass saw, which has a blade that tapers from the handle, and with a coping saw, which has a very narrow blade held in place by adjustable screws. Although more specialized saws are available, most sawing jobs can be accomplished with these items.

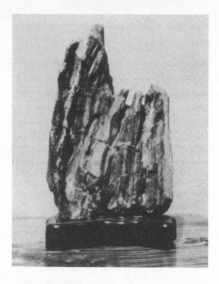

Fig. 148. Dry waterfall stone set deep in a dai. The depth of the dai complements the verticality and heaviness of the stone. Place of origin: United States (California).

CHISELS, GOUGES: Several sizes of chisels and gouges will also be needed. Chisels have a straight cutting edge, and gouges have a curved cutting edge. Chisel and gouge widths start at ⅛ inch and increase by ⅛-inch steps up to 2 inches. Dai carvers use a large variety of chisels and gouges; a professional carver may have well over a hundred in all different shapes and sizes. Clearly, a beginner does not need such a large range of tools. A few chisels and gouges in the popular widths—¼, ½, ¾ and 1 inch—will be adequate for all but the most difficult jobs. Other tools can be added as the need arises.

SHARPENING STONE: Because cutting tools have to be kept sharp, a sharpening stone will be needed. A double-sided stone with fine and coarse surfaces, about 8 inches by 2 inches by 1 inch, is the best choice. For wetting the stone, thin lubricating oil is commonly used.

MALLET: Another item in the basic kit is a mallet. Most dai-carvers own a carpenter's mallet, but some prefer a round-headed stonemason's mallet. Hammers, because they have small faces and are made of steel, are unsuitable for striking a chisel with a wooden end. Chisels with resilient plastic handles may be used with a steel hammer; however, the small face of the hammer area may make hitting the end of the handle difficult, especially when attention is concentrated on what is happening at the cutting end of the chisel.

OTHER BASIC TOOLS: A list of miscellaneous tools that may also be use-

ful would be almost endless, but some basic items worth including are a good knife, a rule, a square, screw clamps or a bench vise, a plane, an assortment of rasps and files, a cabinet scraper, a scratching awl, sandpaper, emery cloth, and paintbrushes. The basic tool kit can be supplemented with several power tools. Some of the most useful power tools are a band saw, for cutting curves; a router, for cutting a predetermined depth into the wood and for making a smooth-bottomed recess; and an electric drill with sanding-disk and drum-sander attachments. An electric drill can be made considerably more useful and precise by attaching it to a drill press.

Design and procedures

Before carving begins, a rough sketch should be made of the suiseki in its proposed dai. A dai is traditionally kept as simple and unobtrusive as possible, never competing with the suiseki for attention. An elaborate dai with intricately carved legs and several walls (discussed below) would be appropriate only for a heavy, rough, or complex stone.

PREPARATORY STEPS: The first step is to choose an appropriately sized piece of wood. The board should initially be several inches longer and wider than the suiseki. The thickness of the board should also be proportional to the height of the suiseki, since without glued-on additions, the height of the finished dai can be no greater than the height of the board. In general, the ratio of the height of the dai to the height of the suiseki ranges between 1:4 and 1:9. The average ratio is between 1:5 and 1:6, meaning that a 1-inch-deep dai might be made for a suiseki that is 5 or 6 inches high. For flat or delicate stones the ratio of dai to stone is slightly less, while for tall stones the ratio is slightly greater. In general, a dai for a flat or delicate stone will be shallower than a dai for a tall, vertical, and more massive stone (see Fig. 148).

Working on a flat table or on a workbench, the board should be planed until it is as smooth as possible. For this step and all other carving procedures, the board should be clamped to the table or work bench, thus allowing both hands to be used for better control and safety.

The suiseki is then placed on the board and, with a pencil, the exact outline of the base of the stone is traced. This can prove difficult if the bottom of the stone is not flat. Some carvers deal with the problem by shining a flashlight on the stone from directly overhead and by tracing along the outline made by the shadow of the stone. Alternatively,

some carvers cast a flat-bottomed model of the suiseki using clay, putty, papier-mâché, or other materials, and then transfer a tracing of the cast to the board. Dividers and calipers are useful for checking the measurements of the model against the measurements of the stone.

WALLS AND INNER HOLLOW: If the dai is to have only one wall (Fig. 149), the carver traces a second line on the board outside the original pencil line outlining the stone's base. A uniform distance should be kept between the two lines. The distance between the lines is determined by the desired width of the wall. There is no set rule on how wide to make the wall; however, a dai for a 10- to 12-inch-long Mountain stone will typically have a wall that is ⅛ to ¼ inch wide. A dai with only one wall is generally appropriate for very simple suiseki.

If the dai is to have two walls (Fig. 150), the carver traces a third line outside the second line, again keeping a uniform distance between the lines (Fig. 151). The distance between the second and third lines (the width of the outer wall) is typically the same or two to three times the distance between the first and second lines (the width of the inner wall). To illustrate, if the distance between the first and second lines is ⅛ inch, the distance between the second and third lines might be ⅛, ¼, or ⅜ inch. The exact proportions are determined by the aesthetic judgment of the carver.

As can be seen in Figure 152, the walls of the dai are carved to resemble steps or terraces, the inner wall being higher than the outer wall. Not counting the height of the dai's legs, the inner wall is typically one-fifth to one-third the height of the outer wall.

The ratios for the two-wall design also hold for a three-wall design; that is, the height of the innermost wall would be one-fifth to one-third the height of the middle wall, which, in turn, would be one-fifth to one-third the height of the outermost wall. A dai will rarely have more than three walls, since such a dai would almost certainly overpower the suiseki.

At this stage some carvers prefer to cut out the outline of the dai using a saw; however, other carvers prefer to saw the outline at a later stage in the process, arguing that this allows greater room for change.

The next step is to carve the dai wall and to hollow out the inner area in which the stone will be laid. Hand tools—such as a mallet, gouges, and chisels—or an electric router may be used. The shape of the wall is determined by the shape of the stone and by individual taste; the wall

Fig. 149. One-wall dai.

Fig. 150. Two-wall dai.

can be carved with either a flat or rounded top. All carving with gouges and chisels should be done with the grain of the wood. If the bottom of the stone has been sawn flat, the inner area should be carved to an even depth and should be as shallow as possible. Although a hollow ⅛ to ¼ inch deep will usually cover the edge of the stone, it may be necessary to carve deeper for a suiseki with a defective or unusual base. The hollow is carved by initially cutting a short distance inside the original contour line and then cutting toward the center of the board, removing waste wood bit by bit. When all the waste wood has been removed, the carver works back to the original contour line with chisels and gouges (Fig. 153). According to the shape of the stone, the sides of the inner area will be either straight or curved. When the carving is completed, there should be a snug fit between the suiseki and the dai. If the dai is well designed and carved, it will continue the line of the suiseki and

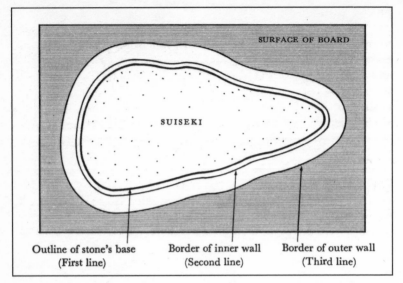

| Outline of stone's base (First line) | Border of inner wall (Second line) | Border of outer wall (Third line) |

Fig. 151. Gutting guidelines for a two-wall dai drawn on a wooden board prior to carving.

will cover the bottom of the stone. Gaps that remain between the stone and the dai can sometimes be filled in with wooden insets or plugs that are glued to the dai and then finely sanded (see Fig. 13).

The inner area is more difficult to carve if the bottom of the suiseki is uneven. Carving must proceed with an appreciation of irregularities in the underside of the stone. The most common procedure is to press the suiseki onto a piece of carbon paper that has been placed carbon side down over the board. The carbon paper is then removed and areas marked with carbon are carefully dug out. The process is repeated until the stone is properly seated.

As a substitute for carbon paper, some carvers mark the bottom of the suiseki with india ink, chalk, or a felt-tip pen. Other carvers find it helpful to cast a model of the stone's base, since this is easier to handle than the stone. Dimensions are then taken from the model and used to guide the carving.

If the fit between the stone and the dai is not snug, or if the stone tends to wobble, some carvers fill the hollow with a mixture of wood shavings and glue. The suiseki is then pressed into the mixture, but removed before the glue sets. With few exceptions, suiseki are never

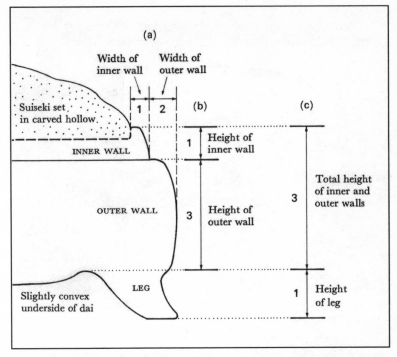

Fig. 152. Cross section of a two-wall dai showing proportions of the walls. (a) Outer wall is typically between one and three times wider than inner wall (in this figure, two times wider). (b) Outer wall is typically between three and five times higher than inner wall (in this figure, three times higher). (c) Ratio of height of leg to total height of the two walls is typically 1:3.

glued to the dai, since a stone is often removed for summer display in a suiban or for examination during competition.

Occasionally a hollow for the suiseki is not carved. If the stone has a naturally flat base, or if the base of the stone has deep indentations and arches, a hollow may be unnecessary, and the top surface of the dai can be left flat or only minimally carved (see Fig. 56).

LEGS: Since the legs of a dai are one of the first elements to be noticed, it is important that they be well designed and constructed. Several variables need to be taken into account, including the shape, height, width, thickness, number, and placement of the legs. As viewed from the front, the sides of the legs can either be straight or curved; from a side view, the legs can be straight, concave, convex, or a combina-

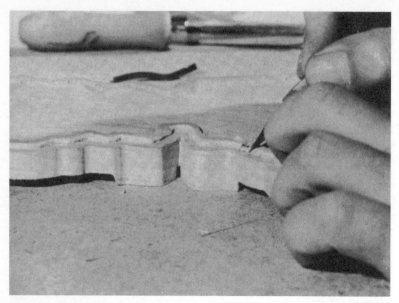

Fig. 153. The hollow for the suiseki has been carved out and further attention is paid to shaping the inner wall.

tion of forms. One of the most common designs is a wedge-shaped leg that is wider at the top than at the bottom; a more rounded design in which the top is narrower than the bottom is also popular (Fig. 154). Often, the front side of the leg is carved so that it curves slightly inward (see Fig. 152). The design that is finally chosen should be based on the shape of the suiseki. A delicate suiseki with soft, rounded contours might have a dai with short, simple legs that are also rounded and curved. A more rugged and massive stone might have a dai with taller, straighter, and more intricately carved legs.

Balance, stability, and aesthetics are primary considerations in determining the height, width, thickness, and placement of the legs. Most dai have four or more legs; dai for tall, vertical suiseki are an exception, since they often have only three legs. For stability, a dai carver will almost always place a leg at each end or corner of the dai; for added stability, one or more legs are also positioned directly below lateral extensions or projections of the stone (Fig. 155a). However, some suiseki do not have such projections. In these cases the legs are positioned below areas of visible weight or below major features of the stone (Fig. 155b).

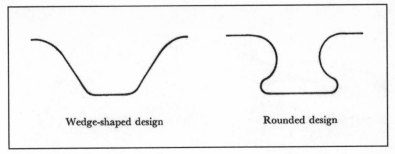

Wedge-shaped design **Rounded design**

Fig. 154. Front view of typical dai legs.

Since simplicity is the key to a successful design, the total number of legs should be kept to a bare minimum. To avoid symmetry, unequal amounts of space should be left between the legs. A leg should also not be placed in the exact center of the dai or under tunnels and gaps in the stone.

A typical ratio between the height of the legs and the total height of the walls of the dai is 1:3 (see Fig. 152c). It should be kept in mind, however, that rarely is more than a ½ inch of space left between the bottom of the dai's base and the ground. If too much space is left here, the excess space will create a feeling of emptiness and instability. Conversely, if too little space is allowed, the dai will appear too squat.

There is no general rule governing the width of the leg. Most dai carvers cut the outer part wider than the inner part, making the leg stable and better able to bear the weight of the suiseki (Fig. 156).

UNDERSIDE: The underside of the dai is often carved in a slightly convex shape. Especially near the center, the wood is kept as thick as possible, since a dai with a thick center is less likely to crack under the weight of the suiseki. Some traditional carvers complete the work by cutting a design, such as a flower pattern, on the underside of the dai.

Finish

Because wood is porous, a finish is often applied to protect the wood from dust, grime, and rot. A finish can also be applied to improve the appearance of the wood. Some woods, such as teak, mahogany, ebony, rosewood, and other hardwoods have a beautiful natural grain, a pleasing color, and natural properties that sufficiently protect the wood. Most other woods need some form of treatment.

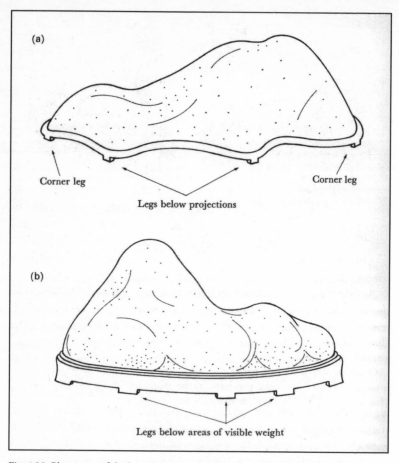

Fig. 155. Placement of dai legs. Legs are carved (a) at each end of dai and below projections, and (b) below areas of visible weight.

PREPARATORY STEPS AND SANDING: Before any finishing material is applied, the surface of the dai should be smoothed to a fine, silky condition. The smoothing of the surface is done with sandpaper, starting with relatively coarse paper and proceeding by steps to sandpaper with a finer grain. Occasionally emery cloth, files, and cabinet scrapers are used to prepare the wood; steel wool is often used for the final smoothing. Sanding is one of the most important processes in the making of a dai and must always be done with great care, regardless of whether

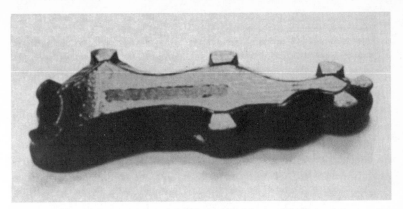

Fig. 156. The underside of a typical dai, showing the shape of the legs.

it is done by hand or with a power sander. If care is not exercised, the surface will be a mass of scratches.

Sanding should always be done following the grain of the wood—never across the grain. It is also important that sanding be done using straight strokes and even pressure. Twisting or circular motions should be avoided. Some carvers wipe the dai with a damp cloth and let it dry after the final sanding. This raises any bent fibers, which can be rubbed off by a light final sanding with a very fine or extra-fine grade of sandpaper. Inwardly curved surfaces can be sanded by wrapping sandpaper around a short length of wooden dowel (the diameter depending on the depth of the curve). After sanding, all dust should be carefully removed, first with a brush and then with a cloth.

BLEACHING: Bleaching is necessary only when the color of the wood needs to be lightened, or when it is necessary to remove any dark spots or other discolorations in the wood. Some carvers feel, however, that such marks add to the charm of the finished piece and prefer to leave them when they are not intrusive.

STAINING: Stains are used to bring out the full beauty of the grain or to deepen the color of the wood. Stains are usually not used on a dai that has beautiful grain or rich color, such as a dai made of rosewood, mahogany, or teak. The surface of such a dai needs only to be polished with sandpaper and rubbed briskly with a cloth. A stain may be applied to add color and darken a wood that has little natural beauty of its own. It will not obscure grain and will only change the color of the

wood at its surface. Consequently, a finishing coat of shellac, varnish, or lacquer must be applied over the stain in order to protect it from unsightly scratches.

OIL AND WAX POLISHING: Oil or wax polishing can produce a beautiful finish. The application process is, however, extremely time-consuming, since the oil or wax must be applied numerous times. As a result, oil and wax finishes are rarely employed.

SHELLAC, VARNISH, AND LACQUER: For years shellac was a favored finish because it was quick-drying and easy to apply. Varnishes were also used, but they had several drawbacks, including a lengthy setting time. In recent years, many dai carvers have come to prefer fast-drying, black or dark brown brushing lacquer because it is hard, durable, and waterproof. Upon drying, a lacquered or shellacked surface will be smooth and glossy. Most carvers reduce this gloss to a soft, satiny finish by rubbing down the completely dried final coat (usually there are four or five coats) of lacquer or shellac with extrafine sandpaper and steel wool until the desired sheen is achieved. It is customary to cover the final lacquer or shellac finish with two coats of wax.

PAINTING: Paint obscures the grain of the wood, and is often used to cover a dai that lacks beauty of color and grain. Both an undercoat and topcoat of paint will be needed. The undercoat—which may be labeled undercoat, flat, or primer, depending on the brand—should have no gloss. The topcoat, which is nearly always glossy and frequently black in color, may be a high-gloss, semigloss, or satin enamel. After several thin coats of enamel have been applied, with light sanding between each coat, a beautiful final surface can be obtained by rubbing the last coat to a fine, soft polish with pumice powder and lightweight oil.

Suiseki Classification Systems

BY SHAPE

Scenic landscape stones (Sansui kei-seki 山水景石/Sansui keijō-seki 山水景状石)

1. Mountain stones (Yamagata-ishi 山形石)
 - (a) Distant mountain stones (Tōmagata-ishi/Enzan-seki 遠山石)
 - (b) Near-view mountain stones (Kinzan-seki 近山石)
2. Waterfall stones (Taki-ishi 滝石)
 - (a) Thread-waterfall stones (Itodaki-ishi 糸滝石)
 - (b) Sheet-waterfall stones (Nunoda-ki-ishi 布滝石)
 - (c) Dry waterfall stones (Karedaki-ishi 枯滝石)
3. Mountain-stream stones (Keiryū-seki 渓流石)
4. Plateau stones (Dan-seki/Dan-ishi 段石)
5. Island stones (Shimagata-ishi 島形石)
6. Slope stones (Doha-seki/Doha-ishi 土玻石)
7. Shore stones (Isogata-ishi 磯形石)
 - (a) Reef stones (Araiso/Araiso-ishi 荒磯石)
 - (b) Sandbar stones (Hirasu/Hirasu-ishi 平州石)
8. Waterpool stones (Mizutamari-ishi 水溜り石)
9. Coastal rock stones (Iwagata-ishi 岩潟石)
10. Cave stones (Dōkutsu-ishi 洞窟石)
11. Shelter stones (Yadori/Amayadori 雨宿り)
12. Tunnel stones (Dōmon-ishi 洞門石)

Object stones (Keishō-seki 形象石)

1. House-shaped stones (Yagata-ishi 家形石)

Thatched-hut stones (Kuzuya-ishi 茅舎石)

2. Boat-shaped stones (Funagata-ishi 舟形石)
3. Bridge-shaped stones (Hashi-ishi 橋石)
4. Animal-shaped stones (Dōbutsu-seki 動物石)
5. Bird-shaped stones (Torigata-ishi 鳥形石)
6. Insect-shaped stones (Mushigata-ishi 虫形石)
7. Fish-shaped stones (Uogata-ishi 魚形石)
8. Human-shaped stones (Sugata-ishi 姿石/Jimbutsu-seki 人物石)

BY COLOR

1. Black stones (Kuro-ishi 黒石)
2. Jet-black stones (Maguro-ishi 真黒石)
3. Red stones (Aka-ishi 赤石)
4. Blue stones (Ao-ishi 青石)
5. Purple stones (Murasaki-ishi 紫石)
6. Golden-yellow stones (Ōgon-seki 黄金石)
7. Yellow-red stones (Kinkō-seki 錦紅石)
8. Five-color stones (Goshiki-ishi/ Goshiki-seki 五色石)

BY SURFACE PATTERNS

Plant-pattern stones (Kigata-ishi 木形石)

1. Flower-pattern stones (Hanagata-ishi 花形石)
 (a) Chrysanthemum-pattern stones (Kikumon-seki 菊紋石/Kikka-seki 菊石)
 (b) Japanese plum-blossom-pattern stones (Baika-seki 梅花石)
2. Fruit-pattern stones (Migata-ishi 実形石)
3. Leaf-pattern stones (Hagata-ishi 葉形石)
4. Grass-pattern stones (Kusagata-ishi 草形石)

Celestial pattern stones (Genshō-seki 現象石)

1. Moon-pattern stones (Tsukigata-ishi 月形石)
2. Sun-pattern stones (Higata-ishi 日形石)
3. Star-pattern stones (Hoshigata-ishi 星形石)

Weather-pattern stones (Tenkō-seki 天候石)

1. Rain-pattern stones (Amagata-ishi 雨形石)
2. Snow-pattern stones (Yukigata-ishi 雪形石)
3. Lightning-pattern stones (Raikō-seki 雷光石)

Abstract pattern stones (Chūshō-seki 抽象石)

1. Tiger-stripe-pattern stones (Tora-ishi 虎石)
2. Tangled-net-pattern stones (Itomaki-ishi 糸巻石/Itogake-ishi 糸掛石)
3. Pit-mark-pattern stones (Sudachi 巣立)
4. Snake-pattern stones (Jagure 蛇ぐれ)

BY PLACE OF ORIGIN

Kamogawa river stones (Kamogawa-ishi 加茂川石)

1. Kurama stones (Kurama-ishi 鞍馬石)
2. Kibune stones (Kibune-ishi 貴船石)

Setagawa river stones (Setagawa-ishi 瀬田川石)

Nachiguro stones (Nachiguro-ishi 那智黒石)

Kamuikotan stones (Kamuikotan-seki/ Kamuikotan-ishi 神居古潭石)

Sado red stones (Sado akadama-ishi 佐渡赤玉石)

Ibigawa river stones (Ibigawa-ishi 揖斐川石)

Sajigawa river stones (Sajigawa-ishi 佐治川石)

Furuya stones (Furuya-ishi 古谷石)

Seigaku stones (Seigaku-seki 静岳石)

Neodani stones (Neodani-ishi 根尾谷石)

Index